SANTERÍA

GARMENTS

AND

ALTARS

Folk Art and Artists Series
Michael Owen Jones
General Editor

Books in this series focus on
the work of informally
trained or self-taught artists
rooted in ethnic, racial, oc-
cupational, or regional tradi-
tions. Authors explore the
influence of artists' experi-
ences and aesthetic values
upon the art they create, the
process of creation, and the
cultural traditions that
served as inspiration or per-
sonal resource. The wide
range of art forms featured
in this series reveals the im-
portance of aesthetic ex-
pression in our daily lives
and gives striking testimony
to the richness and vitality of
art and tradition in the mod-
ern world.

SANTERÍA GARMENTS AND ALTARS

SPEAKING WITHOUT A VOICE

Ysamur Flores-Peña and Roberta J. Evanchuk

University Press of Mississippi Jackson

This book is dedicated to
Dorothy Flores
colleague, friend, and wife
of Ysamur Flores-Peña
and to
Manuel Vargus, grandfather
of Roberta Evanchuk

Illustration and photography credits:
Vincent L. Evanchuk, front cover, pp. 8–11;
Ysamur M. Flores-Peña, plates 1–3, 7, 10, 11,
14–17, 19, 21, 37, 39; Michael Owen Jones, plates
4–6, 8, 9, 12, 13, 18, 20, 22-33, 38, p. 27; Roberta
J. Evanchuk, plates 34, 35, 41, p. 28; Odo Femi,
plates 36, 40; Ernesto Pichardo, plate 42; Chicago
Tribune, p.33.

Library of Congress Cataloging-in-Publication Data
Flores-Peña, Ysamur.
 Santería garments and altars: speaking without
a voice / Ysamur Flores-Peña and Roberta J.
Evanchuk.
 p. cm. — (Folk art and artists series)
 Includes bibliographical references.
 ISBN 0-87805-705-6 (cloth). — ISBN 0-87805-
703-X (paper)
 1. Santería vestments. 2. Santería altars. I.
Evanchuk, Roberta J. II. Title. III. Series.
BL2532.S3F56 1994
299'.64—dc20 93-48420
 CIP

British Cataloging-in-Publication Data available

CONTENTS

THE AUTHORS of this volume met in June 1987 at a seminar on the religions of the Cuban/Hispanic diaspora. Ysamur Flores-Peña, a priest of Orisha worship, gave a lecture on various aspects of his life as a spiritual leader and practitioner of the religion. The grandson of the owner of a coffee plantation in Guaynabo, Flores was born in San Juan, Puerto Rico, in 1953. The dominant religion in Puerto Rico is Catholicism. However, Lucumi is considered the unofficial central religion because many people practice both. Flores had no early interest in Orisha worship. He expected to enter the Jesuit seminary and hoped to become a Catholic priest. At the age of eighteen he suffered a severe back injury, which left him with only a five percent ability to bend his back and the prospect of eventually being unable to walk. He visited a *santero* (priest). After using various offerings and prayer, he began to recover. He was initiated as a Lucumi priest in July 1981.

Roberta "Robin" Evanchuk received her master's degree in folklore and mythology in 1977. In 1989 she began work toward a Ph.D. While studying folk dance, she became interested in performance aspects of the religions of the Caribbean, specifically Vodou and Lucumi. She began to visit Flores and his wife, Dorothy, at Turey, their religious shop in Los Angeles. Eventually the couple agreed to become informants for Evanchuk's dissertation on performance aspects of Orisha worship. In the spring of 1990 Flores announced that he too was entering the graduate program in folklore and mythology. Evanchuk joined the religion in the fall of 1991. Although not yet a priestess, she is a practicing member of Orisha worship.

Thus the authors incorporate the roles of informant, ethnographer, colleague, and practitioner in their approach to the subject of altars and outfits of Orisha worship. Flores grew up knowing of the religion; Evanchuk discovered it as an adult. Flores's research centers on communication of information through the religious objects, Evanchuk's on the altar builder as artist and performer. Evanchuk interviewed Flores as priest and artist, while Flores has recorded Evanchuk's reactions as his godchild and a member of his *ile* (house, or congregation). As insiders in the religion and its art, they are self-reflective while also striving to maintain a disciplined detachment and objectivity when studying others as well as themselves. The provocative mixture of these properties creates an unusual methodology.

The current growth in Orisha worship has stimulated research and publications about the religion. Most books and articles, however, say little about Lucumi art and artists. Many authors dwell on the religion's history, focus on its beliefs and practices, or speculate about its development and growing popularity. Holding to a pri-

vate and discreet belief system, Lucumi practitioners do not ordinarily display their altars and sacred wear to the general public and nonbelievers. However, the authors have been permitted to gather for this book illustrations of ceremonial and sacred objects. Photographs, though not prohibited in some situations, make believers uncomfortable. In addition, the complicated and elaborate rituals leave little time or space for lights, cameras, and photographers. But since it is through their art that practitioners communicate with Olodumare (God), the Orisha (spiritual beings), the Egun (ancestors), and each other, some knowledge of Lucumi art is important to an understanding of the religion.

In the first part of this volume, Flores, the priest and artist, describes and analyzes some of the experiences, concerns and influences that affect his and other priests' designs of consecration garments. In the second part, Evanchuk characterizes and interprets altar construction, drawing on her own observations and on interviews with Flores and others.

In describing and analyzing selected aspects of religious art and ritual the authors have broken no pacts and breached no security with other members of Lucumi. For example, the garments worn during initiation are worn again only at the end of life, and it would not be considered proper for the initiate or anyone else to model them.

For this reason, the examples shown are not displayed on human devotees. Items that must not be seen by nonpractitioners remain hidden. The only objects that appear are those that the users and creators consider it acceptable to show. Before discussing consecration garments and altars, we provide an orientation to the religion. This includes an introduction to its spiritual beings and their sources of power. Orisha worshippers already possess this knowledge, which is why their devotional objects can "speak without a voice."

The authors wish to thank our editor, Michael Owen Jones, for his help in the creation of this volume. Also, special thanks go to Bienvenido Duranza, Vincent L. Evanchuk, Sergio Figueroa, Dorothy Flores, Esteban Garcia, Miriam Gonzalez, Mr. and Mrs. Jose Lopez, Odo Femi, Ana M. Peña, Claudio Perez, Ernesto Pichardo, Luis Ramos, and the costume division of the Department of Theater, Film, and Television at the University of California at Los Angeles.

We gratefully acknowledge support for research through the Arnold Rubin Award, administrated by the Fowler Museum of Cultural History, University of California at Los Angeles.

SANTERÍA is one of the religions that originated with, but is now separate from, African practices in Southwestern Nigeria. The religion took shape in Cuba during and after the slave trade in the late eighteenth and nineteenth centuries. Migration inevitably extended from the Caribbean into the United States, and many Afro-Caribbeans brought their beliefs and practices with them. Though no official count has been made to determine the number of people who practice the religion within the United States, in 1988 officials in the city of Miami reported approximately fifty thousand practitioners and the same estimated number was reported for the city of Los Angeles in a 1989 report by the Los Angeles Animal Regulation Department. These preliminary figures suggest a rapidly increasing membership especially in large cities such as New York, Miami, Los Angeles and Chicago. The original Yoruba belief system from which it sprang is still practiced in Western Africa.

While "Santería" seems to be the term most frequently heard in this country (usually on television news reports attempting to link members with sensational activities such as drug dealing or human sacrifice), most believers find the word offensive, like the negative and unflattering names given to other faiths by extremists or racists. Believers prefer the less controversial Lucumi (a contraction of a Yoruba word meaning "friend"), Orisha worship, or

Afro-Cuban religion when referring to their faith.

Many hear about Orisha worship only from television news reports due in part to the fact that the leader of the drug smuggling ring at Matamoros happened to be a Cuban-American. Since the religion is widely practiced in Cuba, believers were constantly and incorrectly linked to this tragic event. Two popular horror films of the 1980s, *The Believers* and *Angel Heart,* one of which featured the sacrifice of children, were loosely based on the Santería religion, though in fact human sacrifice has never had a place in the rituals of the religion. The movies reflected fears generated by the controversy surrounding the right to sacrifice animals in the Orisha initiation ritual. Though the animals sacrificed are used for feeding those who attend the ceremonies, problems have arisen with animal regulation departments. In June 1993, the Supreme Court of the United States handed down a ruling upholding the right of the believers of Orisha worship to use animals in their initiation ceremonies.

Those who encounter the faith for the first time are naturally curious about the nature of the spirits known as Orishas. An Orisha is a spiritual being that possesses a divine power. Each Orisha in the pantheon is a patron of an idea or of occurrences in nature. For example, there are Orishas representing thunder, fresh water, or the sea. Others symbolize the hunt, death, or

7

birth. In these aspects they are quite similar to angels or saints in other religions. In Cuba Spanish was and still is the dominant culture and language. Aspects of Catholicism were freely borrowed by this religion and the identification of Catholic saints with the deities of Orisha worship became common. More than a mere disguise or survival tactic the practice of venerating deities of other religions continues. Because Catholic saints exhibit attributes similar to the Orishas they are considered equally worthy of worship by Lucumi members. Believers construct statues and altars to honor the spirits just as in many other faiths. Each Lucumi adherent believes that everyone in the world will be protected and supported during his or her lifetime by a particular Orisha; this notion is similar to the concept of a "guardian angel." An individual does not choose the guardian Orisha. The knowledge is acquired by divination, through a specialized system of forecasting in which cowrie shells are read by a priest. Though a believer will honor and ask favors of other Orishas, only one Orisha will be his or her personal patron forever.

A priest/priestess is the person who can sponsor and initiate people into the religion. The words *padrino* or *madrina* are Spanish terms meaning godfather/mother. The words are titles of respect used by members of the religion to address those priests or priestesses who have initiated

them into various levels of the religion. The high priest *(babalawo)* can consecrate his equals and is also one of the religious officers who can determine the identity of an individual's guardian angel. (The *babalawo* shares this responsibility with priests and priestesses. Consequently, though an entrant into Orisha worship cannot pick his or her own Orisha, each has the option of choosing a godparent.)

Many of the smaller popular religions have no solid central authority as larger belief systems do. Therefore standards of design and rules of behavior in ritual procedures in religions such as Orisha worship depend upon divination and a general consensus of the believing community.

The Pantheon of Orisha Worship

The religious arrangement of Lucumi deities places its origins with the gods of the Yoruba in West Africa. Like the Yoruba belief system, the pantheon of Orisha worship is organized under one God, Olodumare. He is not an Orisha but is God the father of all. He conceived the world and everything in it. Olodumare also produced the Orishas or divine entities that care for creation and act as God's agents. The Orishas represent all the individual aspects of creation; every human being is thought to fall under the protection of at least one of them.

One group of Orishas existed before

Eshu-Elegba, Orisha of the crossroads.

the introduction of humans. A second set appeared after people walked upon the earth. Those in the first group govern aspects of nature such as rivers, the sea, trees, deserts, clouds, the sun, and the moon. The second set are human and consist of those ancestors who, because of their *ashe,* or divine power, became deified. In order to keep communications open between human beings and gods, the Yorubas devised two major divination techniques and taught specialists how to interpret them. These systems, used by practitioners of Orisha worship as well, consist of Ifa, the paramount oracle of the religion, and the *awo merindilogun,* or sixteen cowrie shells. A symbol of wealth in many cultures, the cowries are used in Lucumi as part of a highly complicated divination system. A comparable but far simpler procedure is the western custom of tossing a coin to aid in a decision. Each of the approximately 200 Lucumi Orishas has particular colors, numbers, domains, and character traits associated with it. A body of intricate stories contained in Ifa illustrate the reasons for such symbols. Assorted instruments, such as rattles, drums, or bells also serve each Orisha. The devotee sounds these implements in order to obtain the attention of the divinity, as hands are clapped before the altar in some Eastern religions. Among the best-known deities are those described below.

Eshu, Elegba, or *Elegua,* stands at the center of the cosmic crossroad between the human and the divine. This divine communicator carries messages from God and the Orishas to those on earth. Like Dickens's Artful Dodger, he is a cunning deceiver and a mischief maker. Eshu keeps the divine power called *ashe;* his good will must be obtained for projects to succeed. Tradition names Eshu as the organizer and first instructor of the divination systems. His colors are red and black or black and white, which represent the opposites of life. His sacred numbers are three, seven, eleven, and twenty-one. The rattle serves as his instrument.

Human beings must appease Eshu in order to keep life in balance. This delicate balance between positive and negative life the Yoruba call *ntutu* or "coolness." Having no concept of absolute evil, the Yorubas believe evil is a simple misuse of *ashe.* Restoring the balance produces the return of *ntutu.*

Obatala, "King of the White Cloth," is the oldest and wisest Orisha. He created the human body, which God then gave life. From there he took on the task of organizing human society in partnership with the Orisha Orumila. Obatala is everyone's father, regardless of which Orisha rules one's head. Considered the purest of all the Orishas, Obatala's associated color is white, sometimes accented with red, purple, or green. His special numbers are eight and sixteen, and his metal is lead. He

Obatala, Orisha of purity, creator of the world and humanity.

Ogun, Orisha of war and industry.

Ochosi, Orisha of justice, the hunt, and the chase.

owns a special instrument, a silver bell or *agogo*. As an elder Orisha, he possesses many appearances, some male, some female, and one androgenous.

Ogun is the Orisha of the forge and of war; hence he is a violent deity. His colors are green and black and his numbers are three, seven, and twenty-one. Iron is sacred to Ogun; individuals who work with iron implements consider him their patron. The instrument that "speaks" to this Orisha is the rattle, a tool frequently used to communicate with many of the Orishas.

Ochosi or **Oshosi** controls the hunt and the chase. Ochosi, Elegua (Eshu) and Ogun form a triad known as "the warriors." Ochosi supervises the dispensation of justice. The jail, where offerings are frequently taken, is his metaphorical mansion. Often hunted like animals, slaves called upon Ochosi to save them from the hunters as well as from injustices. Blue and gold belong to Ochosi; the numbers three, seven, and twenty-one (like the numbers of Ogun and Elegua) represent him. His instrument for communication is the rattle.

Shango, the fourth *alafin* (king) of the Oyo empire, is the Orisha of fire, both the physical manifestation and the fire of life and human energy. He epitomizes manhood and masculinity. Many stories in the *Odu* corpus of divination tell about his prowess and his gluttony. Like the trickster Eshu, his best companion, he loves parties. Shango's colors are red and white. He fre-

quently holds his symbol, the double-headed ax. His numbers are six, four, and twelve, and his instrument is a rattle.

Oya rules whirlwinds and storms and is the gatekeeper of the cemetery. The favorite wife of Shango, Oya always accompanies him when he goes to war. She is a masquerader and oversees the rituals of the dead (the ancestors). She is also in charge of the marketplace. She dominates all colors and should have at least nine to represent her. Her number, nine, is associated with transformation and death. Her symbol is a scythe or sickle, which she uses to sever all ties when human physical existence comes to an end. Her instrument is the seed pod of the flame tree, used as a rattle to speak to her. Her metal is copper.

Yemaya, the mother goddess of the Orishas, rules over maternity and the peace of the home. The perfect mother, she will not reject any child. She lives in the ocean. Calm and dignified, Yemaya is a great mystery. Believers say, "No one knows what lies beneath her seven skirts." Yemaya's colors are blue and silver, sometimes accented with coral and green. Her number is seven. Her metal is silver and her instrument the rattle.

Oshun presides over rivers and sweet waters. She is the goddess of love, fertility and the beauty of life. Sensual and vain, exquisite and refined, she is an arduous lover and compassionate mother. She is a scholar and a leader of women in dealing with

Shango, or Chango, Orisha of battle and masculinity.

Oya, Orisha of the market and gatekeeper of the cemetery.

Yemaya, Orisha of the sea and the peace of the home.

their male counterparts. Olodumare created Oshun, his favorite daughter, to embody all the graces he may have left out when fashioning the world. Her colors are yellow and gold, her metal is brass, and the peacock serves as her messenger. Her numbers are five, ten, and twenty-five. Her instrument is a brass bell.

Ibeji are divine twins called *Taiwo* and *Kainde*. These children are the joy of both humans and Orishas. Messengers of happiness and prosperity, they also effectively overcome the most awesome difficulties. Whenever the big Orishas cannot act, the little Ibeji will save the day. Offerings to them must be in pairs. They have a great fondness for children and are their special protectors. Their altars are filled with candy and toys (plate 1). Their number is two and their instruments are rattles.

Babalú Aye presides over disease. Some believers have recently included AIDS in the list of infectious diseases controlled by him. The image of Babalú Aye changed from that of a feared deity in Africa to a loving and compassionate one in the Caribbean and the United States. Though most rites for Orishas take place in the daytime, ceremonies for Babalú Aye must take place at night (plate 2). Unlike most Orishas, who favor water for ritual purposes, this Orisha abhors it. Yellow and purple are considered a standard combination for Babalú Aye. His number is seventeen, and his instruments are the rattle and the cowbell.

Osanyin or *Osain* is the Orisha of herbalism, magic and the power of nature. The life-giving forces of nature are summed up in this sacramental phrase of the priests of Osanyin: "The green blade is mightier than the iron blade." Osanyin has no parents; "he appeared like the grass." As punishment for greed (he did not want to share the secrets of herbalism), he has only one eye, one ear, one arm and one leg. Osanyin's voice is very low, almost a whisper. A gourd covered with many colored beads contains his secrets. His symbol is the Ozun, the metal staff of the herbalist. It is made of a small rod topped by a small container, and crowned with bells and birds. Osanyin's colors comprise all the colors of nature; his symbol is a bell or a rattle and his numbers are seven and twenty-one.

Oshun, Orisha of love, sweetness and sensuality.

Ibeji, the twins, protector of children and messengers of joy.

Babalú Aye, Orisha of infectious diseases.

Osanyin, Orisha of herbalism, magic and medicine.

11

IMAGINE the second day of your own consecration as a priest or priestess. You must keep your eyes closed while a dozen or more officiants dress you. You hear "ahhhh," "beautiful," "gorgeous!" You wait anxiously while they adorn you with heavy necklaces criss-crossed over your chest. The last necklace represents your Orisha, and then the final item, a crown, is placed upon your head. The officiating priests and priestesses order you to open your eyes. Now you see others' smiles and admiring nods, but still you do not see yourself.

This scene repeats every time someone becomes a priest or priestess in the religion of the Orishas. The mystery and wonder of the event focus on the altars and garments designed and made for this momentous occasion. The new priest or priestess has heard about the garment but has not seen it because secrecy surrounds its creation. The garment's debut must be a surprise for everyone. The *yabo* (sometimes spelled *iyawo,* it is a Yoruba word meaning "bride" and applied to both male and female initiates) soon discovers that all mirrors have been covered because the initiate must not see his or her reflection. As people come in to greet the altar and the *yabo,* comments abound about the beauty of the garment and its harmony with the Orisha depicted. Everyone has something to say, noting an exceptional detail here or the excellent use of color there. Although pleased and excited, the initiate becomes increasingly frustrated because of the lack of a mirror. I remember well the feelings I had at my own initiation twelve years ago. According to tradition, I was allowed to wear the outfit only for six hours. "God," I thought, "I hope someone comes in soon wearing Ray-Ban glasses so I can see myself." It didn't happen.

Though the details of the consecration ceremony will not be discussed here, the event is generally divided into four main parts: first, the private rites of actual consecration; next, a period when the public is invited to visit with and pay respect to the new priest; third, the divination period when the destiny of the new initiate is determined; and finally, the re-introduction of the priest into the processes of everyday life. The initiation lasts seven days.

The garment highlights the whole consecration ceremony and becomes one of the most beautiful memories of one's religious life. The clothing becomes for the initiate a "garment of glory." Once a person dons it, the outfit transforms him or her into a new being. The yabo resembles a phoenix born again, resplendent and full of divine energy. The consecration garment must be beautiful; no expense is spared, and sometimes the garments cost the initiate hundreds of dollars. Having brought the initiate into the world, the garment will also carry that person out of it when he or she faces Olodumare, God; that is, it serves as a burial outfit. As visitors look

THE
GARMENTS
OF
RELIGIOUS
WORSHIP

YSAMUR
FLORES-PEÑA

13

around the room they see that the colors of religious objects match. The altar, the garment, and everything else related to the consecration chamber must be the color(s) of the initiate's patron Orisha. The color and numerical coding create the Orisha's presence through symbols.

The consecration garment together with the *mazos* (necklaces) and bangles weighs many pounds. The weight seems to increase every time the wearer must prostrate himself or herself before the many senior priests or priestesses as each enters the room. Going down to the floor presents no problem, but getting up becomes a taxing proposition. After all, one does not want to wrinkle the garment. At the end of the day people remember and converse about how entrancing the yabo's garment is. The initiate listens intently for he will never see what they have seen.

The Nature and Functions of the Consecration Garment

The basic models for consecration dresses resemble the high-style clothing in vogue in sixteenth- and seventeenth-century western Europe. All the models derive from styles considered "regal" and that identify the black royalty with the white ruling class. Over time, certain patterns became fixed; different artisans reproduced them with only slight variations (e.g., plate 3; this garment and others illustrated here are on

mannequins because, according to Lucumi belief, the outfits may not be phtographed on a living person). Availability of embroidered materials and decoration influenced the dressmaking trade. As sectors of the population other than blacks and mulattos took up Orisha worship, more expensive and elaborate fabrics came into use, though the models remained much the same.

The consecration garment, also known as *traje del medio* (outfit for the middle day), will be worn by the new priest or priestess only three times: first, on the *día del medio,* or second day of the consecration from noon until 6 o'clock when he or she sits in state to receive visiting priests and friends; second, on the *día del medio* of the consecration of the next priest or priestess in line; third, at burial. The examples in this book have been worn during the first two phases and await their final use as burial clothing. The psychological impact and feelings of awe inspired by these outfits overwhelm the new priest and visitors.

The person dressed in a consecration outfit becomes transfigured into the Orisha whose garment he or she is wearing. The interplay of colors and decoration gives the initiate a divine dimension. In order for a consecration ceremony to be considered aesthetically pleasing it must reflect the values assigned to the Orisha being honored. These values find expres-

14

sion through the selection of objects and offerings. For instance, an altar for Shango, god of lightning, should reflect his masculine qualities and capture his sense of boasting. An altar for Oshun must convey the distinctive values associated with a goddess of love, sweetness, and sensuality. When you ask a priest his opinion about a ceremony, he will give you a judgment based on whether all the elements fit together harmoniously to achieve the intended purposes—education, communication of stories, transmission of values, and character of the Orishas. Thus a priest has to know both the old traditions and the emergent ones. A priest on the east coast of the United States will not make the same aesthetic judgments about design, color shades, or garment shape as one on the west coast. Influences include environmental details, ethnic diversity in the area, tastes in the community that witnesses the ceremony, or the personal tastes of the priest. All of these criteria influence the event. People who watch this physical and spiritual transformation judge the priest's assertiveness in choosing material, textures, and colors. They will want to know if the *Pataki*, or story transmitted through the outfit, is being adequately rendered.

The consecration outfit, or *traje del medio,* is created for the second day of initiation ceremonies when the initiate wears the symbols of the Orisha and becomes the living representation of that deity. The garment must consist of the color(s) and display the number sacred to the Orisha, and include implements that characterize in visual terms the personality of the divinity (for example, a fan for Oshun or a double-headed axe for Shango). The garments and decorations must impart a picture of the divinity to the beholder. In other words, the consecration outfit creates the Orisha in the body of the initiate.

The consecration outfit serves three major purposes. First, it identifies the newly initiated with the Orisha to whom he or she is consecrated. The outfit elevates the initiate to the level of the Orisha, allowing him or her to share the dignity and power intrinsic to the divine being. It is an opportunity for the new priest to experience the sacredness of his or her newly acquired status and to incarnate the divinity for others as well.

Second, the garment communicates aesthetic values intrinsic to the cult. To be considered successful, a priest or priestess must not only know the ceremonies and organization of the ritual elements, but also convey them through the diverse symbolic objects present in the ceremony. All elements, including the clothing worn by people attending and even the dishes used, must be related in color and texture so as to create a harmonious environment that is associated with the Orisha to whom the initiate is consecrated. Furthermore, the priest will accent the ceremonial objects

with components that remind the participants of the Orisha being honored, such as wearing a garment with the color or decorations of the Orisha and giving to those who attend mementos appropriate to that Orisha. When all elements are in harmony, everyone fully participates in the ceremony not only physically but also aesthetically. If the process is successful, the priest is said to be "speaking without a voice."

Third, the consecration outfit visually educates everyone who participates by summarizing the most important events in the life of the deity. Special care must be taken to expose the new priest or priestess to the different aspects of the religion. This task is especially important in the United States since people come into the Orisha worship tradition from other cultural backgrounds. The educational process that traditionally occurs during a lifetime must happen more quickly for adults who did not grow up in the religion. When I was consecrated into the priesthood I already had much of the formal and informal knowledge of Orisha worship.

The consecration outfit poses the greatest challenge to any priest, requiring more dramatic changes than other elements of the ever-growing, multicultural nature of the religion in the United States. For example, African-American priests often draw from African traditions in garment design. Asian-Americans reflect their own culture and taste as do other ethnic groups who join the religion.

Creating new garments entails developing new forms or modifying conventional ones. The consecration outfit must be consistent with the accepted views as defined by the oracular tradition and the elders of the community. The religion is based on two fundamental principals: following the words of Orishas through divination and the honoring and worshipping of ancestors.

The oracles of the religion, Ifa and Dilogun, contain in their corpus of stories the summary of the culture. Every important question presented to the deities through the oracle answers and guides the devotee. The oracle is regularly consulted on matters of marriage, child-rearing, and business ventures to name but a few. Each one of the Odu or divination verses explains and justifies the ceremonies and processes in the religion.

Worship of ancestors includes a practitioner's personal forebears but focuses on the honoring of religious progenitors, including, of course, the Orishas.

When one becomes consecrated and learns the identity of his or her Orisha, a series of teachings begins that communicates the character traits of the Orisha to the initiate. Once the initiate becomes familiar with the ever-expanding nature of the deity and places the inner persona in the mythical universe of the Orisha, she or he becomes an "actor" in the ceremony

and participates more fully in it.

Almost everyone in Orisha worship knows the *pataki,* or sacred stories. Consequently, when a consecration takes place, the priest must combine appropriate elements within the ceremony in order to tell a well-known story in a new, dynamic, and original way, but still within traditional boundaries. The priest or priestess not only tries to be appropriate when staging a ceremony, but also to communicate his or her own view of the theology. Any idea must be in harmony with the community's ethos and yet remain true to the individual's own precepts and values.

The art of dressmaking allows room for innovation in the religion. Seamstresses traditionally have been the ones in charge of designing and making garments. Given the opportunity, most priests in Orisha worship will participate in the design process by, for example, adding elements from their own ethnic backgrounds or their own personal styles to the garments used in their *iles* or houses. Not everyone in Orisha worship, however, feels comfortable enough with alteration, fitting, and trimming to design an outfit in its entirety.

I myself became involved in designing because I felt that constructing altars and creating a unique garment are as much a sign of devotion as the ceremonies themselves. Everything related to the Orishas is for me a religious expression.

I began designing altars and garments because I wanted my godchildren to realize that I cared enough for them to provide for their individual experiences something unique, beautiful, and truly their own. After initiation one possesses the Orishas and the implements permanently. Seven days later, however, the beautiful throne is gone. The handsome garment that was worn with such pride for a few fleeting hours changes meaning as the yabo is undressed at the end of the middle day and changes into simple white clothing.

Designing the Consecration Garment

When I design a consecration garment there are many things I take into account. First I must consider the Orisha to be presented through the garment. Is the Orisha female or male? Old and venerable or full of life and possibilities? I always like my garments to reflect heaven. The person who becomes the Orisha's mirror must look like an apparition from the spirit world. Lots of lights and reflections. Because the garment tells a story, the individual wearing it must identify not only with the consecration processes but also with the requirements of the plot and the expectations of the people who come to see the new priest/Orisha. To design a garment is to dream, to be a storyteller whose medium is the fabric.

Sometimes designs actually come to me in a dream. Once after many nights of con-

17

sidering various patterns and styles, I dreamed I saw a woman coming out of the ocean wearing a dress with a high collar studded with cowrie shells and designs that looked very cryptic and that resounded with powerful voices (plate 3).

The crown was tall and stately (plate 4). I told my seamstress about the basic design and where I wanted the shells to go. I also said, "Fill it with cowries. This *traje de santo* is a messenger of wealth." Yemaya is a matron, the mother of the Orishas. But the Yemaya that I was to consecrate was young and full of life. So I dreamed a young Yemaya, one that was still at the beginning of the world on her way to heaven to request from Olodumare a husband in order to make the newly created world bloom.

The front of this garment is an abstraction of a growing plant with a flower bud containing seven cowries representing seeds inside. The crown, taller than others, also contains cowries. The shells resemble the plant at the base of the garment, but this time the bud has opened in full bloom (plates 5 and 6).

The garment in plates 7, 8, and 9 represents *Asesu*, a road of Yemaya associated with the shore of the sea and the foam. This information is traditionally conveyed with baby blue materials. The blue organdy with silver embroidery represent the water and transmit the message of the foam. Seven layers of darker blue lace and a train communicate the sacred number

associated with Yemaya. The embroidery suggests the multicolored effect of sea foam when it's in the air with the sun reflecting upon it.

I must also consider the gender of the initiate. I do not like to dress men in the customary fashion of the masculine priests of Oshun. I designed the garment in plates 10, 11, and 12 for a male priest of Oshun. The Aphrodite of the Yoruba pantheon, a beautiful and seductive Orisha, Oshun exists in a realm of immense splendor. The absolute mistress of the sweet water, she is herself the epitome of sweetness. Designing a garment for a male was a challenge because the Orisha in question is female. I wished to tell a story of splendor and luxury and also to present Oshun as the learned woman she is. This posed an interesting problem in composition and style.

The consecration ceremonies took place in Caracas, Venezuela. The room in which the throne or altar was constructed faced south, allowing the afternoon sun to come straight through the wide window and door. I decided to place the throne so it would face the window and to use material that would shine but with the sparkle on the garment itself. I used the Yoruba *abada* (a loose-fitting outer garment); instead of cotton I selected gold lamé (plate 10). I hoped that when the sunlight streamed through the window, the throne would glow softly and the *abada* would

"burn" brightly. I designed a modified shirt underneath but kept the traditional wide sleeves. The whole shirt bears abstract designs in green (plates 11 and 12). This combination depicts Ololodi, the avatar of Oshun who is married to Orumila (the Orisha of wisdom and divination); through this alliance Oshun gained access to wisdom. Instead of the traditional knee-length pants I used full-length ones. It worked. The afternoon sun lit up the room, and the yabo looked magnificent. When the room was full of visitors, I removed the outer garment to reveal the completely different garment underneath. Everyone was surprised and seemed pleased. The crown resembled a small hat made with the same material as the abada (plate 13).

The traditional way of presenting male consecration garments calls for a shirt in the color of the Orisha with allegoric designs. The garments produced by other seamstresses and designers illustrate this in examples of Shango (plate 14) and Oshun (plate 15). Another example, a shirt for Obatala, whose sacramental color is white, has a monstrance on the front. The monstrance associated by some with Obatala creates a pun referring to Obatala's purity and high status in the religion. Instead of using white over white as in the first example, the seamstress chose silver.

The preference in length of the pants for a male priest is almost evenly divided. Some will use only a plain white trouser while others use knee-length pants in the color of the Orisha. When women become priestesses of a male Orisha, they wear male outfits, except when the Orisha is Obatala, in which case they wear female clothing.

The garments in plates 14 and 15 follow the more traditional style of garments for males. The Shango garment (plate 14) belongs to a well-known and highly respected priestess in Los Angeles, Miriam González. The six bars on the front identify Shango's number; compare this with the design of the Oshun shirt (plate 15). Although made by different seamstresses, both shirts share common motifs in design, such as the gold bars to identify the Orisha; six for Shango and five for Oshun plus the gold trim on the cuffs. Even though the design on the Oshun garment is different (chevrons instead of the straight trim on the Shango garment), the basic pattern remains the same. The collar almost always shows the same form in shirts for male initiates. Similar stylistic concepts can be found wherever the religion thrives. Both outfits basically copy the same pattern with only those differences in number and color that identify each Orisha. My Oshun garment (plates 10, 11, and 12) was markedly different from the two examples above, breaking all the current conventions of a male garment by its changed pant length, shirt style, and additional outer garment. I do not know what I will do the next time I

consecrate a male priest. While it is an accepted convention for female initiates to wear male outfits if the Orisha to be consecrated is male, males consecrated to female Orishas do not wear female clothing.

My mother was a seamstress. I can recall her activities hours after we were put to bed when she opened her much-used Singer and began to sew. Sometimes when the neighbors came to her with impossible requests, she had to force the material to yield. She would scribble an abstraction of the pattern. I realize that many of the prototypes I take to my seamstress resemble my mother's designs, difficult in detail areas and rarely standard in concept. The garment in plate 16 belonged to my mother, the late Ana M. Peña, and is a good example of a fundamental Puerto Rican garment design. The striking simplicity of the style and pattern gave an air of cool dignity to a mature priestess (she was initiated in 1985, when she was fifty-eight years of age). The designer chose the sunflower as a symbol of Oshun and, rather than being placed in only one area, the flower decorations appear on the sleeves and front panel of the skirt. Like my mother, I prefer to mix materials and designs as they often do in Puerto Rico. Once the viewer has become immersed in the arabesques of the garments, the eyes must rest. Some garments, however, unlike those with more complex and heavy designs favored in the islands, should be simple.

My most unpretentious garment is an exercise in light and dark blues (plate 17). The woman who wore the dress wanted something more subdued (without rhinestones or flashy colors), "not as scandalous" as the one worn by her mother, who had been consecrated by me a year before (see plate 7). I decided to experiment with lace. I wanted to create a dress that could produce light instead of only reflecting it. The lace, already very heavy, becomes even more so when lined. The alternating panels of light and dark blue became the focal point of the dress (plate 18). If the yabo stood, the dress became dark and unassuming, but when she moved, the light came from within, suddenly revealing a sense of lightness and playfulness that reflects from different angles. For the altar I used a very light blue material so the contrast of light and darkness would give a sense of motion to the whole.

Altars and garments of other Orishas, because of their complexity, present unique opportunities to interpret the Orishas' stories. One excellent chance for innovative interpretation occurred when a priestess of the Orisha Oya was to be consecrated. Oya, Orisha of the market and gatekeeper of the cemetery, also rules the winds. Closely associated with the Egungun (ancestors), she is the Orisha of transformation and a masquerader. It always makes news whenever a devotee of Oya becomes

consecrated. Everyone wants to witness one of the most respected and rarely consecrated Orishas because of her association with death. Oya can be represented by nine different colors. Elusive and mysterious, she became a challenge to me because I did not want to make the entire garment consist of nine colors (which would make the initiate look like a circus tent). However, the nine colors embody Oya's personality. Oya's praise name, Iya Mesan (mother of nine), refers to the time when, childless, she made *ebo* (sacrifice) in order to become a mother. She bore nine children, represented by the nine streams of the Niger Delta (her river) in Africa. I wished to convey that story.

The basic decision I had to make was whether to do the dress in nine full colors or to play with the design, not breaking with the convention but stretching it a bit (plates 19 and 20). Because of Oya's association with Shango, I could use red or burgundy. I chose burgundy and "drew a river" of nine colors flowing from the left shoulder through the front, curving gracefully to the train at the back, and made of lamé. In the back, from the right shoulder and also from the left, the nine bands run to meet the bands on the train. Two years after the consecration took place, a friend saw a picture of the garment and mentioned that the dress looked like "water flowing." He had not heard the story, nor did he know the mythology of Oya. I was pleased that he "read" the dress as the story that it is, an indication of the success of the design.

For the crown, I went back to my original clothes style. I used a Harlequin type of crown with points curving to the outside. On the inside are the same colors that are on the nine panels in the garment (plate 21). This can be seen only when the wearer nods or kneels; then the whole effect is transformed (she is the transformer). Around the crown nine large rhinestones of the same color as the panel match the colored bands both outside and inside the headdress. A crystal bead hangs from the tip of each point of the piece. When the *yabo* wore the crown, by sheer accident the sun entered the window and hit the beads; sparks of light and color filled the room, again "transforming" everything.

Another outfit I designed for a priestess of Yemaya was commissioned by my wife Dorothy for the first person she would consecrate as a priestess. I did not want to use my favorite shiny materials such as brocade or lamé. Instead of capitalizing on light, I decided to focus on texture. I used a cotton brocade without a sheen to make the bodice, sleeves, and train. I designed an organdy skirt and sleeves coming from underneath the brocade to give the sense of delicate airiness (plates 22 and 23). The name Yemaya (she is also called Omi Yeye or "mother of waters") means that water flows from her body to nurture creation.

21

This garment became a tribute to that characteristic. The name of the priestess, Omi Bi ("the birth of water"), becomes a wonderful pun for the garment.

Storing the Garments

Generally speaking it is the priest who keeps and stores the initiation garments of his or her godchildren, the priests he has consecrated. The closet space in any home, designed to store less imposing attire, must be expanded to accommodate all the outfits. Considering that a priest will consecrate dozens of people during his or her lifetime, the number of garments to be stored can be daunting. The closet also serves as a showcase. When a priest wants to demonstrate how successful his or her practice has been, the number of outfits speaks for itself. I have arranged the outfits in my home chronologically, in the order in which they were used. Displaying them gives an idea of how models and ideas have changed over time. Storage was not a problem when the religion remained limited to the islands; each house contained a room for worship with ample space for the garments. When I moved to Los Angeles, the house in which I lived did not have so much room. However, a reorganization of the rooms and closets gave me the space to accommodate religious items. Locking them away in a storage building, no matter how secure, is unacceptable. I

feel that the storage area is as much a part of the sacred space as any other element of the *ile*. Other priests who are also beginning to reconceptualize and redefine sacred space share this notion.

Traditionally, the crowns for initiation have no material inside with which to cover the top of the head. I had never considered this to be a good model because it shows the bare head of the initiate, which must be shaved for the ceremony. I felt that since many details of the ceremony take place in secret, the design painted on the head should certainly be covered when the general public arrives to greet the *yabo*. I designed a crown that covers the top of the head with material from the basic outfit (plate 24). This helps conceal the sacred design on the head from the eyes of those non-initiates who are attending the presentation of the *yabo* during the *dia del medio* celebration.

This style presented a problem because the crown cannot be easily folded for storage (plate 25). I experimented with other crowns, making them open and adding a separate skull cap. But it didn't work. At the moment I have returned to my original design because I actually prefer to change the closet rather than alter the beauty of the crown.

In the Miami area most priests and priestesses no longer keep the garments in storage for their godchildren. Instead, they give the outfit to the new priest or priest-

ess after the consecration rituals have been finished or after the presentation of the initiate to the drums. The justification for the change is the population's increased mobility; many priests and priestesses feel that if needed the garment should be readily available. Also, because of modest storage areas it is easier to keep one complete garment than several, and adequate space may be found if the outfit remains in the custody of the owner.

The Seamstress

Because of its religious meaning, the consecration outfit contains a highly complex conceptual and aesthetic symbolism. To create such an item challenges the designer, who must not only have a knowledge of history, but also a sense of beauty. For a ceremony to be successful, the components must combine to produce a meaningful religious and artistic experience for all who see it. The seamstress chosen to construct the consecration garments uses her designs to produce such an experience. Normally the priest or priestess does not interfere with the artistic decisions of the seamstress. Frequently they will give the seamstress full reign over design, color, and sometimes even choice of material. She knows what needs to be accomplished, and she may reconfigure and adjust designs to produce a handsome outfit. Thus the seamstress plays an impor-

tant part in shaping the community's sense of beauty through her creation and presentation of the garments. But this noninterference policy is changing. I am not the only priest who has become interested in working with the seamstress to design garments. In some cases no longer the sole decision maker, the seamstress may now form a creative partnership with the priest.

My association with the seamstress Dolores Pérez is a cordial one, and we effectively combine our knowledge when we work. An important part of our relationship consists of the mutual trust we have developed, even though she still points out how long it takes to work on my designs! Seamstresses have such an overwhelming amount of work that they often standardize their patterns, and everyone ends up with the same model in different colors. A priest who is more involved can bring fresh ideas into the process by producing new forms and reevaluating existing ones. To this end, priests are careful to communicate regularly with the seamstress. Frequent discussions and exchanges of ideas between seamstress and officiating priest will insure that the consecration outfit will be pleasing to both.

Priests in major centers such as New York, Miami and Chicago still trust Dolores Pérez to design and manufacture their outfits. Her name commands respect and admiration. Her sense of color, balance, and finesse makes her one of our

most skilled craftspersons. As a priestess, Dolores is familiar with the Oracle, the religious tradition, and the tastes of the communities she serves. Wearing a Pérez outfit is rather like wearing an Oscar de la Renta creation and can be a source of pride in the community and for the individual. Dolores's creations bear her trademark in details such as a loop made of fabric or sequins (plate 23) located somewhere on the basic design. She skillfully blends multiple textures and materials and can work in exquisite detail (plate 26). In many instances her creations, which are not limited to garments, can make an altar come to life, saving the altar builder much extra work.

Paños

Dolores also makes *paños* (altar cloths to cover the pots of the Orisha). These *paños* can be considered garments for the Orishas; on their own, they are true works of art (plates 27-31). The cloth is also used when an Orisha takes possession of a devotee to cover the person possessed. In such a case the Orisha has transferred himself or herself from the pot to the body of the devotee. The priest or priestess will bring the most beautifully made *paño* to honor the *ashe* or spiritual power that has come to dwell in the midst of the people. The Orisha may present this *paño* as a gift to anyone present as a token of love or luck, for healing, or as an icon of the Orisha in that person's home. Some individuals purchase these paños to display in their living rooms as art.

The *paños* made by Dolores Pérez bear decorations that cover all the cloth (plate 27) so that any of the four corners of the *paño* can become the front once placed on the pot. In the *paños* shown in plates 30 and 31, only one corner shows decorations. This indicates a more direct approach requiring that the attributes of the Orisha be made more graphic; design is emphasized rather than the interplay of colors as in some *paños*.

Beading

Another specialty in the religion is the art of beading. The undisputed expert of this craft in Los Angeles is Miriam Gonzalez. Her ability to combine beads of different sizes, shapes, and colors inspires the imagination. Her art encompasses the making of *mazos*, large and heavy ceremonial necklaces. The new initiate, after being dressed in the *traje del medio*, is draped with the *mazos* that represent the Orisha he or she has received (plate 32). In Orisha worship, beads symbolize wealth and royalty. In this religion the words "crowning" and "consecration" mean the same thing. The *mazos* worn by the newly initiated priest or priestess not only reflect the royalty and sacredness of status but also the incorpo-

ration of the *ashe* within the body of the initiate. The *mazos* and the *paños* together form a major part of the decorations on the pots during celebrations. The Orishas will also place a *mazo* on an uninitiated person to indicate the need for that individual to become a priest or priestess. A well-made *mazo* adds to the beauty of any sacred event.

Miriam's beaded items, though naturally heavy, look light and fragile; she is able to combine beads of seemingly incongruous sizes into a solid but delicate-looking *mazo* (the necklace in plate 33 weighs more than three pounds). Her beading technique seems more like knitting, and her use of color and design produces the impression of a painting. People in Los Angeles as well as other communities in the United States and Puerto Rico are willing to wait months to acquire an example of her exquisite beadwork. The use of a good seamstress and a good beadworker allows the devotee to demonstrate to others his or her devotion to the powers of this religion.

The Artists of Orisha Worship

The consecration crowns and clothing do not exist alone. Items such as *paños*, necklaces, and the altar or throne must be harmoniously arranged to produce a vision of heaven on earth. The focus of the consecration—the Orisha, represented by the *yabo* or initiate—will be served through

the use of beauty as a measure of devotion. People such as Miriam and Dolores aid the priests and priestesses in achieving this end.

In regard to my own style and approach in designing outfits, I consider myself "elaborate" in the full sense of the word. Other individuals in the religion are less inclined to express themselves in the same way and, in fact, may be quite conservative in style while still delivering a powerful message. These two approaches to devotion complement one another and are *ntutu* or "cool." In the religion of the Orishas "coolness" (or keeping balance in all things) is the paramount virtue. Its achievement in worship and in life becomes our aim. Whether simple or ornate, an altar that does not achieve tension as well as a calm nobility is not "cool" or effective. Garments must be seen within their own artistic environment. The room that displays the garment as well as the garment itself possesses an aura of sacredness that is timeless. One walks into the presence of an individual who has become transformed; perceptions of everyday reality disappear. Everything is done in an ancient manner. Gourds instead of dishes feed the Orishas. Bodies prostrate themselves in front of a human being elevated into the realm of the divine. That's why consecration garments have an air of timelessness within the altar space. If such clothing were worn in any other environment the wearer

would be considered old-fashioned or even bizarre. However, the individual who dons the garment in its proper setting within the altar space is fully aware of his or her status. Wearing the consecration garment and the crown highlights the experience of becoming a priest or priestess.

The Lucumi community in Miami is also aware of its place in the religious tradition. Important elders reside in this area and act as living references in matters of faith, aesthetics, custom and belief. Many of the trends in the religious tradition can be traced to the practices of this community. Individuals maintain an active exchange between Miami and other areas where the religion thrives. People move constantly, and new believers arrive from Cuba almost every day. The changing availability of materials defines the look of objects used. Aesthetic choices of motifs and decorations in garments and *paños* also change as seamstresses and craftspersons learn what is acceptable in other communities. Therefore, a person from Los Angeles can proudly display an object and just as proudly comment that it came from Miami. An individual in Miami can certainly claim the same about an object designed and manufactured in Los Angeles.

Artists from the east coast and west coast alike are proud of our creations and the beauty they bring to the religion. As a priest and a designer of their garments, I want my godchildren to remember the second day of their consecration with pride. How much people talk about the way the initiate looked during and after the event measures the success of my overall design. Stitched into every inch of the garments are my dreams, my faith, and my personal vision of this religion. I believe Dolores, Miriam, and other artists of Orisha worship feel the same. I claim no more than this.

LIKE MOST PEOPLE who attend ceremonies of Orisha worship, I was drawn at once to the altars. The decorated altar (also called throne or shrine) houses, sanctifies, and calls attention to the honored Orisha or Orishas. Each altar possesses traits linking it to a specific purpose within the religion, but each retains its own unique character, reflecting the personal disposition of the Orisha and the altar maker as well.

The altars, which are usually built in a corner, display a variety of foliage or rich, beautifully suspended fabric. Here the Orishas' accouterments are kept. Objects inside the altars include carved statues, seed pods, fruit, flowers, urns, beads, feathers, cauldrons, miniature farming implements, fans, mirrors and other items that symbolize the Orishas. Supplicants give these objects as offerings for favors received or place them in an appeal for a benefaction not yet granted. Specific rituals are carried out in front of the shrine but even when no special events are taking place, people stand or sit in front of the altars enjoying their variety and artistry.

Although many altars remain in one place for long periods, others are ephemeral, built for a single occasion. When the ceremony has concluded the structures are dismantled and removed. Upon arrival at an *ocha* birthday (the time when each priest or priestess in the religion celebrates his or her individual consecration), or at a *bembe* (a celebration honoring an Orisha), one may see examples of both permanent and temporary altars.

The Yoruba temple in Caracas, Venezuela, contains a fine example of a fixed altar. Dedicated to Elegua (the messenger and trickster Orisha), it stands in his traditionally assigned place near the front door or main entrance to the temple (plate 34). The basic construction consists of leaves, branches, and other greenery setting off the statues of the personal Eleguas of Luis Ramos, his family, and other members of the temple. Usually concrete, the statues generally have a conical or triangular shape. For some recipients, however, the concrete is poured into a conch shell with the opening of the shell acting as the face. The Eleguas possess features made of cowrie shells, and the cheeks display tribal marks. Because of variations in the expressions, each little Elegua appears either to be fiercely peering or shyly peeking out of the foliage. When the greenery wilts or dies, family members or others · bring in new vegetation. In this perfectly created setting, Elegua the trickster, warrior, and communicator does his job: protecting the temple, conveying messages to other Orishas, and "opening the way."

Creating Altars Within Tradition

When I asked Ysamur Flores what he considered to be the most important thing needed in altar building he answered, "A good assistant!" His wife, Dorothy, usually

THE
ALTARS
OF ORISHA
WORSHIP

ROBERTA J.
EVANCHUK

helps as do others. Those specifically requested will lend their assistance, frequently bringing snacks or beverages. A party atmosphere prevails.

Altars usually stand in a living room corner or against one wall. Once the location has been established, shelves, pictures, chairs and other items must be moved and rearranged to accommodate this important new piece of furniture. Tables, considered least important, disappear in favor of chairs so visitors can sit beside or in front of the throne watching the rituals and chatting with one another.

As altar builder, the priest or priestess of the *ile* or home (or the individual member responsible for holding the ceremony) has three to four feet of bare wall to work with. Boxes of fabric and sacred items are brought from a closet or storage area, and the officiant selects materials. Priests or priestesses who have been in the religion for a long time have a large store of cloth and religious objects from which to choose.

Helpers begin ironing long lengths of the material. Others slowly take out creases with a steamer, which is also used on the sacred garments of initiation. After all, the throne houses an Orisha, a sacred spirit, and like the smooth white altar cloth lying beneath the host at a Catholic Mass, these materials are also altar cloths, to be kept clean and well cared for. The materials for altars are considered sacred and are

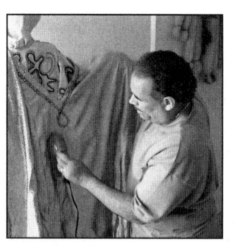

Ysamur Flores-Peña steaming an initiation garment.

Preliminary stages in building an altar for Oshun. Note the use of the corner to define the shape of the altar.

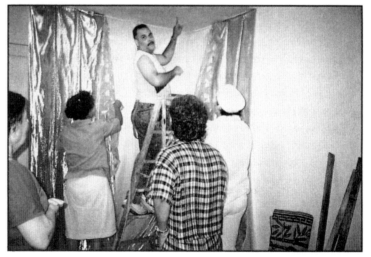

28

never used for anything else once they have been hung in or around a shrine.

After assembling and preparing all the items, the maker begins constructing the throne, which in some cases means covering the wall or corner area with material. This covering serves as the background against which the Orisha or Orishas to be honored will be displayed. Next, the altar maker adds a number of long panels of cloth at each side of the backdrop. These side panels display a multitude of angles, sizes and shapes and are formed according to the character of the Orisha and the decisions of the altar maker. Together with the back material they make up the sides of a small alcove. Using string, wire, pins and other aids, the builder places fabric over the alcove to form a roof or canopy. The final phase of the construction then begins, when the Orisha and other sacred materials are placed within the alcove.

The priest installs the sacred items that embody the actual Orisha, usually contained in large enclosed pots or *soperas*. The space inside the throne becomes sacred, and only those who have been initiated as priests or priestesses can enter. Final decorations include fringe, feathers, fans, and trinkets.

Traditional offerings of fruits and vegetables placed at the foot of the structure add the final decorative touch to the altars. This area is called the plaza (plate 35).

Fruits and vegetables are sacred to each Orisha and generally reflect the color associated with a particular one. Believers place additional foods and other items upon the plaza as gifts and offerings. The presence of the plaza often contributes to an impression that the structure looms larger than it really does. Creation of the plaza, with its candles, fruit and flowers, usually takes place the following day just prior to the ceremony. A skilled builder working with experienced assistants can finish an altar in less than two hours, not counting time for the plaza.

In 1989 I witnessed the building of an altar for the Orisha Oya. Oya manifests herself in various natural forms such as strong winds and fire and in masquerades. Associated with the marketplace and considered a patron of women's leadership, she also has a secretive nature, compared to other Orishas. Orisha worshippers claim that women have the same rights and entitlements as men. Investigators have often pointed out, however, that the position of babalawo is reserved for males. Though this restriction is true, the babalawo can perform his ceremonial duties only with a priestess present performing hers. This procedure helps to maintain a balance of power reflected in Orishas as well as Lucumi principles. Equal to the strength and authority of the male Orishas, Oya stands out as a strong female with a contemporary feminist attitude.

Upon arriving in El Monte, California,

where the work would take place, I discovered Ysamur Flores amidst piles of cloth and various objects that would be placed in and around the shrine. In the room I also noticed the ubiquitous iron and ironing board.

I asked Ysamur if he felt there were restrictions on altar building. "No restrictions whatsoever," he said. But when I asked about putting an "incorrect" item on the altar, something perhaps for a different Orisha, he reconsidered his assessment of how much freedom there is. He explained his acceptance of boundaries: "You keep your limits. You don't want to use one color [associated with] one Orisha to represent another. The tradition tells you the elements of your presentation and with that you work the way you want. It's up to you." Ysamur sees himself as one who is constantly contributing to a tradition, not enslaved by it. Though shrines tend to use a corner space as well as the flat wall in a room, no hard-and-fast rules exist for a specific area of a room or even the basic shape of an altar. Restrictions do govern whether an altar is built inside or outside, and an Orisha must be correctly matched with the proper colors, position within the throne, and symbols. Still, relatively few restrictions govern technique and design. The choice of materials, shape, and overall appearance belongs to the builder. Altar makers often copy designs and techniques from different cultural sources; new concepts and procedures may be incorporated into styles and forms that Ysamur would still call "traditional."

There are those who consider Ysamur something of a maverick, although other builders are also innovative. While Ysamur's altars may sometimes exceed the boundaries of accepted tradition, his deviations seem to be generally condoned. In his own words, "Everyone waits to see just what I am going to do next." His fundamental requirement for an acceptable altar is that it impart the appropriate meaning to those who see it; he "will do whatever it takes to get the job done."

Consider how Ysamur uses objects and colors to "code" or convey the African origins and the marketplace over which Oya (who is always represented by nine different colors) presides:

> When you code Oya, this is my center [he indicates a bright back panel of material]. What I'm going to do is put that [a painted Mexican statue about three feet tall] here, in front of the panel. The statue will convey the same message over and over again. Multicolored. Like a jungle. But the statue at the same time will reflect back and forth all those colors of the material. [The statue is] a Mexican work of art. The reason I'm using it is because of the multicolored part of her dress. That represents Oya.

Ysamur also uses his own design ability and keen color sense to convey a visual message about Oya, one that he considers

traditional. But his means of conveying the message is less traditional (other altar builders may not use Mexican statues or any statues at all). In Orisha worship altars, the symbolic messages about the character or stories connected with a specific Orisha seem to be repeated or traditional, but the means by which the message is sent varies; thus, the builder can exercise a large measure of individuality.

As Ysamur accumulated items for the altar he remarked:

> I have a Mardi Gras mask. Oya is a deity that takes masks. She is a masquerader so the mask is central to her worship. A mask is a mask! That looks awesome. Makes the whole thing get sense. Now we'll decorate the stool [for the statue] with something red! The association with Shango. [Oya is the favorite wife of the Orisha Shango. Ysamur acknowledges this association with Oya by adding Shango's color to the others upon her altar.]

Ysamur delights in working with varied materials and labors painstakingly to achieve precisely the effect he seeks. Metaphorically speaking, if a living room wall represents his canvas and the colored materials his paints, then the humble staple gun becomes Ysamur's paintbrush. A popular tool for most altar builders, the stapler allows the artist easily to hang, fold, pleat, and shape the materials used in the shrine. Each staple must be removed with pliers. Ysamur keeps pliers of various sizes on hand during an altar construction. He selects the materials, staples them in place, then stands away from the wall, surveying what he has done and forming new ideas. The materials go up quickly and come down slowly several times before he is completely satisfied. After Ysamur carefully studies a completed construction for the fourth or fifth time, his helpers (myself included) have a pretty grim idea of what is to follow when Ysamur quietly asks for the pliers.

The ceremony for Oya (no cameras were permitted) took place the day following the creation of the altar. Guests brought fruit, candles, and vegetable offerings to place on the plaza at the feet of Oya, contributing further to the multicolored effect and, finally completing the decoration phase of the throne.

Viewed from the front, the Oya altar, like the shrines of other religions, exhibits aspects of the theatrical stage. According to Ysamur, "When you make an altar you are trying to teach people about [a particular] Orisha. You are trying to let them know how awesome or delicate that Orisha is. You're trying to convey those messages. The throne is supposed to communicate. Thrones can be artistic, beautiful, whatever you want them to be, but if they don't convey the message of the Orisha there is no sense to it." Theater settings, by and large, do the same thing. The set designer seeks to express rather

than represent, to suggest rather than imitate, in order to get a message across. Practical goals for both the set designer and the altar builder include ease of construction and reasonable cost.

Both set designers and altar builders use various types of material in the form of curtains, drapes, and "drops." Ysamur frequently uses the theater-derived word "backdrop" when he speaks of the cloth he places at the rear of the throne. Drapery materials are popular both in religious settings and in theater productions not only because of affordability, but because the simple use of material properly hung and placed can create an illusion as good as or better than one afforded by constructed scenery.

The artists intend for spectators to be able to see everything within the shrine or theater set whether they are seated at the sides or directly in front of the work. To accomplish this, a set designer creates raked sets built on a slant with the narrowest part of the design in the upstage position (toward the back wall of the stage). I have noted the use of this technique in many of the altars. It is probably to facilitate raking that altars are frequently located in the corner of a room. This procedure may have been learned by simple trial and error. However, I suspect that a set designer's use of the laws of perspective does not go unnoticed when believers attend theater productions, and they may consciously or unconsciously copy the technique. In fact, more than theatrical conventions may be appropriated. In an article on altars in *African Arts* (1993), David Brown notes the striking similarity between the royal symbols of the seventeenth-century Spanish court and Lucumi shrines. Practitioners of Orisha worship, Haiti's Vodou belief system, or Brazil's Candomble are well known for their accretive habits and freely borrow whatever seems to work, from wherever they wish.

Altars and Ceremonial Dress

Members of the religion attending ceremonies dress in white, and nonbelieving visitors are encouraged to do so as well. The Orishas favor white because of its strong positive power (*ashe*). Orisha worshippers consider the proper sort of dress for men to include white pants, shirt, shoes, stockings and often a white cap. Women wear a white dress or skirt reaching below the knee, a white blouse with short or long sleeves (sleeveless blouses are not considered appropriate by most believers), white shoes and stockings, and, for participation in the actual ritual, a white headcovering of some sort.

The white clothing rule is relaxed a bit for priests and priestesses as they may also wear the colors of their own patron Orisha. The men prefer to wear short-sleeved shirts of colored gingham. When

32

worn by women, the gingham material often contains white lace trim applied to a dress or skirt and blouse (plate 37). Seamstresses known for their expertise in this type of clothing make some of the standard white garments, but regular department stores can supply most items. The exception to this pattern of dress occurs during the initiation of a priest or priestess. The garments of an initiate or *yabo* far surpass standard clothing in composition and artistic design.

Worshippers also wear jewelry, each item of which represents a level of involvement in the religion. Neophytes of Orisha worship first receive the beaded necklaces (*elekes* or *collares*) worn by believers. The color sequence of the beads of each necklace identifies a specific Orisha. The bead patterns of the Orishas Elegua, Oshun, Obatala, Yemaya, and Shango are those most commonly seen. Beaded bracelets and bangles of metal adorn the wrists of many members.

In 1989, Ysamur created an altar for the initiation of a new priest in his *ile* (house, or congregation). Upon initiation, believers receive a Yoruba name, just as those who receive confirmation in the Catholic church take a saint's name. Because we are speaking of his religious initiation, this priest has requested that we use his ocha name, Odo Femi ("the river loves me"), for this publication because he considers the name equally if not more important

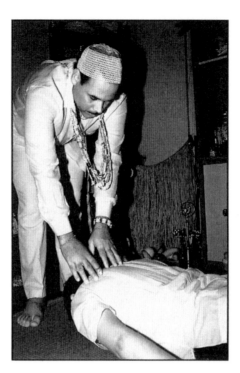

Greeting a senior priest. White clothing is standard wear during ceremonies.

than his original name. Odo Femi, whose patron is the Orisha Oshun, was initiated in the summer of 1989. The initiation took place in Caracas, Venezuela. Before the 1993 Supreme Court decision upholding the right to use animal sacrifice in Orisha worship in the United States, many initiations took place in countries where the practice is not restricted. The altar was built in a small, bare, white room at the rear of a home in Caracas.

The Oshun throne had to be significantly different in message, structure, and function from the altar for Oya discussed earli-

er. In a conversation about these differences, Ysamur remarked, "If any adjective describes Oya it is 'Amazon.' That's why we say 'Obini Mesan,' nine times a woman, a woman worth nine. She is the tomboy of the Orisha."

If Oya is the "tomboy," Oshun is the aristocratic ingenue of the pantheon, a lady to the core. She is Ysamur's patron and "rules his head." Oshun's patrician message influences the color, style, and presentation choices that Ysamur must make for the altar. "When it comes to Oshun," states Ysamur, "I live with her. I am acquainted with her likes and dislikes."

The altars for Oya and Oshun differ not only in design but also in function. The Oya shrine had been assembled to honor an Orisha as personified by the sacred objects placed within it. The one representing Oshun posed new demands, for it contained a ritually dressed human being, the *iyawo* (initiate), Odo Femi.

This particular altar would be, as Ysamur termed it, "a structure within a structure." In this sacred space, for seven days the *iyawo* would eat, sleep, and experience the process of initiation into the priesthood of Oshun. The throne held particular significance for Ysamur because he is himself a priest of Oshun. "It is very special because you're working on something that touches you, and that you know better than anyone else," he said. "I get personally involved in it, more than [with] any

other Orisha. This time I'm doing to someone what was done to me. It's like a constant flashback."

Ysamur has performed initiation ceremonies many times before, but this one made him anxious. As soon as he began to build the structure, I saw some of the reasons for his concern. He intended to test tradition in two major areas, by changing the size of the throne and by radically altering the clothing that the *iyawo* wore. Ysamur has long felt that the standard size of the throne (usually about three feet radiating out from the corner of a room) is unbearably small, especially for a male initiate. A tall, husky man, Ysamur vividly recalls his discomfort during his own initiation when he had to remain in that small space for seven days, leaving only to go to the bathroom. Therefore, he increased the size of this throne by two and one-half feet, giving Odo Femi more space in which to move. This change might be considered by some as extreme. A negative response to the throne from his peers or other well-known altar builders could damage his reputation, but he took the chance.

Ysamur's altar and the initiate who becomes part of it, together, must send a message to those who see it. The same thing happens in theater. In his classic work *Producing the Play* (1949), John Gassner discusses the special techniques for delivering the proper message: "In the theatre we have accepted certain conven-

tions as an aid to quick identification. Not all earnest young professors wear horn-rimmed glasses, but most stage professors do. The dark shell rims on the light face carry well from a distance and 'get the idea across' quickly." He also notes that the designer "must steer a middle course between accepting a stereotype and creating a character which may be true to life but one which the audience will fail to recognize." Flores, like Gassner, recognizes the importance of using the special dress or costume that the *iyawo* will wear to send a message that spectators/audience will recognize.

While Ysamur's reasons for changing the altar involved comfort, his explanations for modifying the *iyawo's* dress concerned style, aesthetics, and taste. He has a negative reaction to the garments for the male initiates of Orisha worship. Composed of a full-sleeved shirt and knee britches in imitation of white eighteenth-century Caribbean slave owners, the clothes look silly today. "I have never liked the male outfit of Orisha worship," said Ysamur. "I *just don't like it.* When I made my *ocha* (became initiated) I told my godmother, 'Don't you dare dress me like that!'" Ysamur is a Puerto Rican with African ancestry; his reasons for disliking the traditional garments of initiation are obvious. Odo Femi is white. In this case Ysamur sees the clothing as a manifestation of the "minstrel dilemma" at its worst: a white

man wearing the clothing of a black man imitating the clothing of a white man! He considered this prospect insulting and distasteful and believed that others would find it offensive as well.

To reduce these incongruities, Ysamur modified the eighteenth-century style by blending it with African and western fashions, an acknowledgement of the derivations of the religion as well as the background of the initiate. "I'm dressing the *iyawo* in a traditional African *abada* [a long sleeveless outer garment]. I'm lengthening the pants [and] the only thing I kept of the traditional elements is the sleeve. I like those sleeves." Because Oshun is a female Orisha and the priest is initiating a male, Ysamur must consider how the *iyawo* will appear to those who see him. "They will want to know how I am going to handle a man without making him look feminine. Well, I have a surprise for them."

When the traditional "middle day" arrived—the third day of the seven—when the initiate would receive visitors the house filled with guests waiting their turn to greet Odo Femi. Seated in the middle of the altar, he truly completed it. The gold *abada* complimented the material used in the throne. The gold crown on his head was simple in style, contributing to the masculine effect Ysamur sought. I was genuinely astonished at its splendor, much to the delight of Ysamur, who said, "I told you it was going to be special!" But the

priest had not yet finished. At an auspicious moment, when equatorial weather and a large crowd had made the room uncomfortable ("Isn't it a bit warm in here?"), Ysamur removed the *iyawo's* outer garment revealing the one beneath (plates 10 and 11). The new long pants and full-sleeved shirt in a different shade of gold added still another dimension to the structure of the altar. "You see? The *iyawo* 'wears' the throne." The visitors, both believers and nonbelievers, were undeniably impressed.

The altar received remarkably favorable opinions from most builders. A notable shortage of negative criticism might have been due to the desire of the faithful to be polite to a visiting priest, and the nonbelievers who were present would not have noticed the changes. Ysamur's godparents did question the altar's size but not the nature of the outfit. One dubious comment came from Ysamur's godmother, a person of high status in the religion in Venezuela. Ysamur has great affection and respect for her. On seeing the throne for the first time she exclaimed, "The *iyawo* doesn't have a throne, he has a whole condominium!" However, a few days later, this same priestess asked to borrow parts of the material used for Odo Femi's throne for a ceremony she herself was planning for the middle of the month. Another request arrived from a female about to be initiated: would Ysamur please design her dress?

Comparing Artists

The initiate Odo Femi, now a practicing priest, must also create altars. He has learned techniques and designs from his godfather, Flores, as well as from others, but his work reveals unique qualities, too. Odo Femi's use of the mask at the crest of his altar for Oya resembles the way his godfather conceptualizes Oya. On the other hand, Odo Femi tends to scale down the size of his altar and to use space quite differently (compare plates 36 and 39). His simpler, smaller construction is more compact and sends the message of Oya with far less material surrounding the shrine. Odo Femi claims that a small apartment is the reason for the more diminutive construction. Though that may be true, most of Odo Femi's altars do not thrust themselves forcefully into the middle of a room as Flores's altars do for his patron Oshun (plate 39) and for others.

When Odo Femi reached the end of his year as a *iyawo* he asked Ysamur for help in constructing his first celebratory altar. Though the major portion of the composition was executed by Ysamur, the material was chosen by Odo Femi (plate 40). The result is an example of two priests with dissimilar styles working together to produce a single altar. Artistic preferences can be detected if the shrine of Odo Femi's first Oshun altar (in which he had control over the material used but had significant

input from his godfather) and Ysamur's Oshun altar are compared. Both Oshun altars are rich and impressive, but Odo Femi tends to use materials that are less "busy" in pattern than does Flores. Although both altars dominate the room, Odo Femi's choice of materials obliges Ysamur to use a different approach when devising the shrine for his godson. Flores constructed the roof of Odo Femi's shrine with a swag effect. He flattened the altar, making it much closer to the back wall. In contrast, Flores's use of bright balloons on the ceiling (plate 39) propels his own altar space directly into the middle of the room and creates a pronounced three-dimensional effect.

Ysamur's way of using material is not found in many altars: he tends to mold the cloth, working it into multiple shapes and designs, then attach these shapes to the back wall of the shrine in what might be called an "appliqué" technique (plate 41). The colors, shapes or patterns in these appliqué pieces represent Orishas, stories about the Orishas, or some aspect of the religion appropriate to the altar being built. Odo Femi and others do not make as much use of the method. This spatial, unrestrained, overlaid manner of working contributes to Flores's special signature as an artist. The style is quite different from the upright, less angular one being developed by Odo Femi.

As in the large metropolitan areas of New York and Los Angeles, the religion thrives in South Florida, mainly because of the continuous arrival of large numbers of people who left Cuba to settle in the United States. I offer here some additional material from Miami neighborhoods in order to point out differences as well as similarities in altar design. The Miami example in plate 42 is a celebratory altar for Shango, patron Orisha of Ernesto Pichardo, a priest who led the highly publicized effort to legalize animal sacrifice in the state of Florida. This altar was constructed on July 4, 1993, to commemorate the United States Supreme Court decision upholding the right to offer animals for religious purposes.

Anticipating that many would attend the celebration, Pichardo had the altar constructed on the premises of the Club Destiny in Hialeah. The altar builder, known as "El Nene" by those who use his talents, is a "professional" builder of altars who makes his living creating and constructing shrines for the large Lucumi community, an emerging vocation in the Miami area and other parts of the United States.

Like Flores in his building of the Oshun initiation altar, El Nene chose to enlarge the size of the Shango shrine, but for very different reasons. Flores expanded his altar for the greater comfort of the *iyawo* who would remain within it for seven days. The Miami altar contained no initiate. And since it remained in place for the Fourth of July

37

celebration only, it was a true example of an ephemeral, temporary shrine. Though it did not house an initiate, the increased dimensions of the Miami altar accommodated it to the much larger room that it occupied, assuring it the stature and distinction this major celebration warranted.

Shango's crimson tones were featured in the Miami shrine much as they would be in Shango thrones in Los Angeles, and his associated emblems and symbols were treated as they are in California. Ernesto Pichardo's religious name is Oba Irawo ("king of the stars"). The Shango altar's decorations represented a fiery path of falling stars in celebration of this unique aspect of Shango (see top of Shango altar in plate 42). El Nene uses patterns and designs of motion to communicate messages about Shango just as Flores did with his multicolored patterns in the Oya altar.

There is a tendency in the Miami area to treat backdrops in a different way from that found in Los Angeles, namely, the astute use of an existing rock wall rather than the addition of a backdrop of fabric. To be sure, material backings are sometimes employed in Florida, but artists often search out interesting formations and patterns on walls, enclosures, or other upright structures within the celebration area. The rock backing of the Shango altar, together with the swaths of cloth that sweep across it, gives the altar depth, as well as calling to mind the motion of falling stars. The powerful nature of the wall re-quires careful consideration of how material and decorations are placed upon it. The angular design, popular in Miami and beginning to appear in Los Angeles, reflects the commanding disposition of this masculine Orisha and adds another strong dimension to the work.

Most practitioners eventually build an altar for themselves. Priests and priestesses in the religion will most certainly do so, but not all will become noted for their efforts. Some will be content to create altars for their own ceremonies but never build shrines for others. Some will become interested in other arts associated with the religion that are more compatible with their own interests and talents. Pursuits such as beading, cooking, music, dance, the growing of herbs, and numerous other endeavors attract those willing to spend the time required to sharpen and perfect their skills.

Individuals who become proficient in one or another art form receive recognition for their work in the community. Gathering designs and ideas from modern and older cultural sources, they stretch the limits of convention while remaining sensitive to others' tastes and opinions. The altars, garments, and other items created by these worshippers can be found in every *ile* and at every ceremony, ongoing expressions of the characteristics of the Orishas, the tenets that the religion embraces, and of the personalities and faith of the designers themselves

References

Abimbola, Wande. 1975. *Sixteen Great Poems of Ifa*. Lagos: UNESCO and Abimbola.

Bascom, William Russell. 1969. *Ifa Divination: Communication Between Gods and Men in West Africa*. Bloomington: Indiana University Press.

Barnes, Sandra T., ed. 1989. *Africa's Ogun: Old World and New*. Bloomington: Indiana University Press.

Bolívar Aróstegui, Natalia. 1990. *Los Orishas en Cuba*. Habana: Unión de escritores y Artistas de Cuba.

Bronner, Simon J. 1981. Investigating Identity and Expression in Folk Art. *Winterthur Portfolio*. 16:65-83.

Brown, David H. 1993. Throne of the Orichas: Afro-Cuban Festive Initiatory and Domestic Altars in African Diaspora Cultural History. *African Arts*. 26 (4): 44-59.

Cabrera, Lydia. 1975. *El monte: igbo, finda, ewe orisha, vititi nfinda: notas sobre las religiones, la magia, las supersticiones y el folklore de los negros criollos y el pueblo de Cuba*. Miami: Ediciones Universal.

Cosentino, Donald. 1987. Who is that Fellow in the Many-Colored Cap? Transformations of Eshu in Old and New World Mythologies. *Journal of American Folklore*. 100:261-275.

Danielson, Larry. 1989. Religious Folklore. *Folk Groups and Folklore Genres: An Introduction*. Elliot Oring, ed. Logan: Utah State University Press.

Dewhurst, C. Kurt, Betty MacDowell and Marsha MacDowell. 1983. *Religious Folk Art in America: Reflections of Faith*. New York: E.P. Dutton, Inc. in association with the Museum of American Folk Art.

Flores, Ysamur M. 1990. "Fit for a Queen": Analysis of a Consecration Outfit in the Cult of Yemayá. *Folklore Forum* 23:47-56.

Georges, Robert A. 1980. A Folklorist's View of Storytelling. *Humanities in Society*. 3:3172-325.

Jones, Michael Owen. 1971. The Concept of Aesthetic in the Traditional Arts. *Western Folklore* 30 (2):77-104.

_____. 1989. *Craftsman of the Cumberlands: Tradition and Creativity*. Lexington: The University Press of Kentucky.

_____. 1993. *Exploring Folk Art: Twenty Years of Thought on Craft, Work and Aesthetics*. Logan: Utah State University Press.

Knight, Franklin W. and Palmer, Colin A. 1989. *The Modern Caribbean*. Chapel Hill: University of North Carolina Press.

Mason, John. 1981. *Onje Fun Orisa (Food For the Gods)*. New York: Yoruba Theological Archministry.

Murphy, Joseph. 1992. *Santería: An African Religion in America*. Second ed. Boston: Beacon Press.

Ortiz, Fernando. 1917. *Los Negros Brujos (Apuntes Para Un Estudio de Etnologia Criminal)*. Madrid: Editorial America.

Pelton, Robert D. 1989. *The Trickster in West Africa: A Study Of Mythic Irony and Sacred*

Delight. Berkeley and Los Angeles: University of California Press.

Perry, J. H., Phillip Sherlock, and Anthony Maingot. 1991. *A Short History of the West Indies.* New York: St. Martins Press.

Pollack-Eltz, Angelina. 1977. *Cultos afroamericanos (vudú y hechicería en las Américas).* Caracas: Universidad Católica Andrés Bello.

Thompson, Robert Farris. 1976. *Black Gods and Kings: Yoruba Art at UCLA.* Bloomington: Indiana University Press.

_____. 1993. *Flash of the Spirit: Africans and Afro-American Art and Philosophy.* New York: Random House.

Verger, Pierre Fatumbi. 1987. *Lendas Africanas dos Orixiás.* Sao Paulo: Editora Corrupio.

Vlach, John Michael. 1978. *The Afro-American Tradition in Decorative Arts.* Cleveland: The Cleveland Museum of Art.

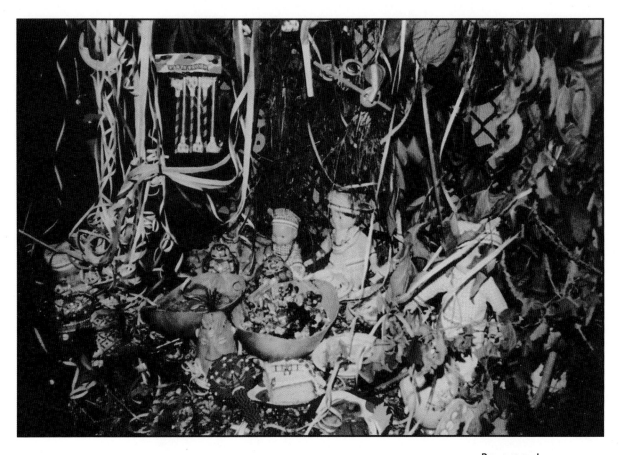

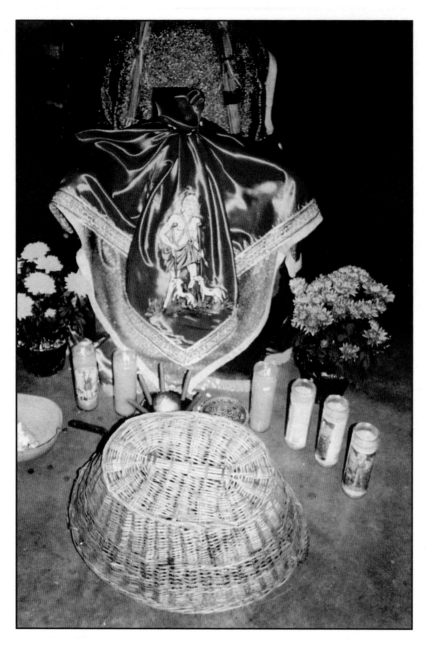

PLATE 2
Altar for Babalú Aye. Ceremony takes place at night. Overturned basket indicates ceremony is finished.

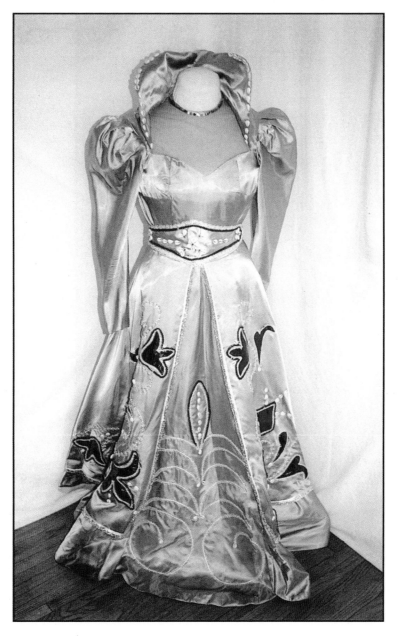

P L A T E 3
Garment for Yemaya.
Blue taffeta, trimmed in
silver and cowrie shells
with lamé appliqué.

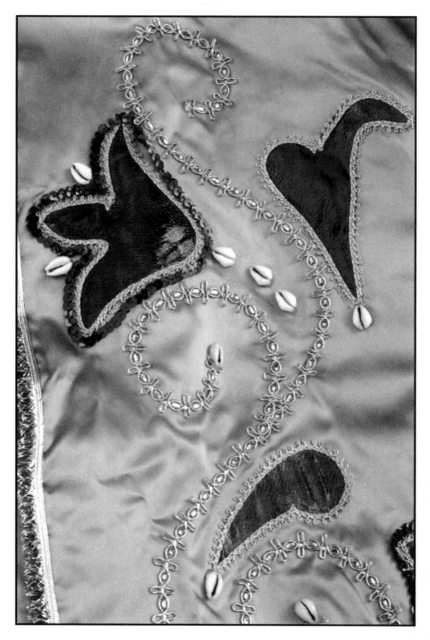

PLATE 4
Detail showing flower design of Yemaya garment in plate 3.

44

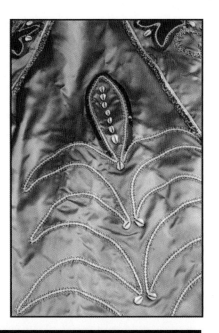

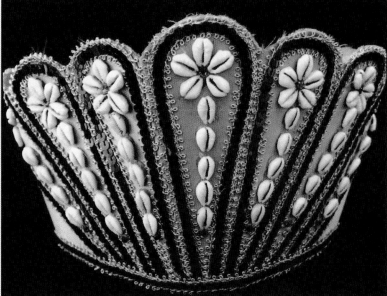

P L A T E 5
Detail of front panel
of Yemaya garment in
plate 3.

P L A T E 6
Crown for Yemaya gar-
ment (plate 17), decorat-
ed with blue and silver
sequins, cowrie shells,
and rhinestones.

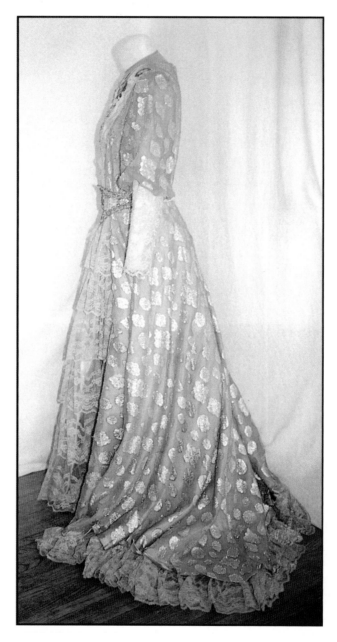

PLATE 7
Garment for Yemaya initiate. Dress is of blue organdy with silver and blue lace. This garment also includes a train and has extensive embroidery on the bodice.

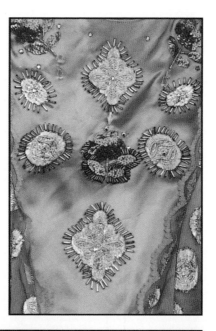

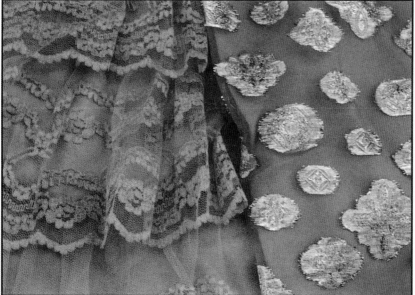

P L A T E 8
Sleeve detail of Yemaya
garment (plate 7).

P L A T E 9
Skirt detail showing or-
gandy and lace materials.

47

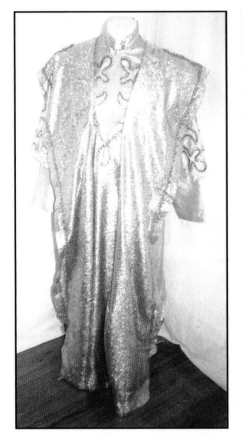 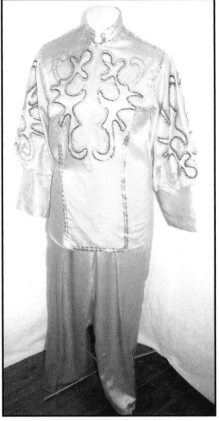

PLATE 10
Garment for male initiate of Oshun. Abada or outer garment, is of lamé with accenting gold trim.

PLATE 11
Garment for male Oshun initiate in plate 10 with abada removed revealing yellow taffeta wide-sleeved shirt with abstract design in green and gold sequins.

48

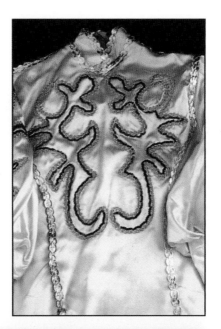

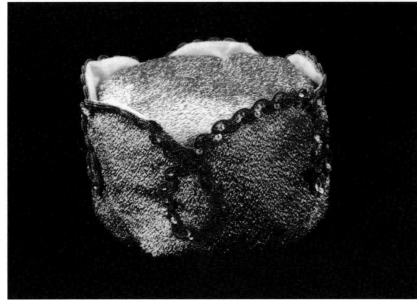

PLATE 12
Front detail of male
Oshun garment in plate
11.

PLATE 13
Crown for male Oshun
garment in plates 7 and 8.
Crown matches abada in
gold lamé with gold trim.

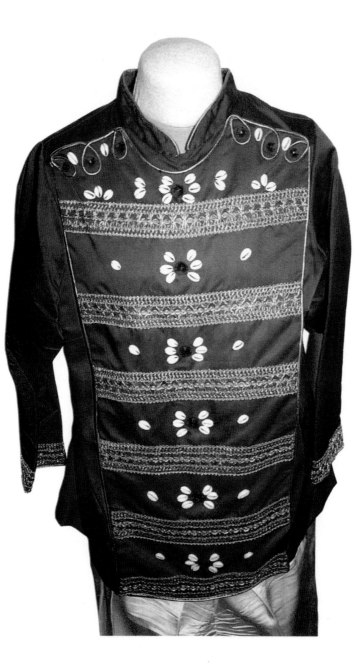

PLATE 14
Garment for female initiate of Shango. Red taffeta shirt trimmed with rhinestones, cowrie shells and gold braid.

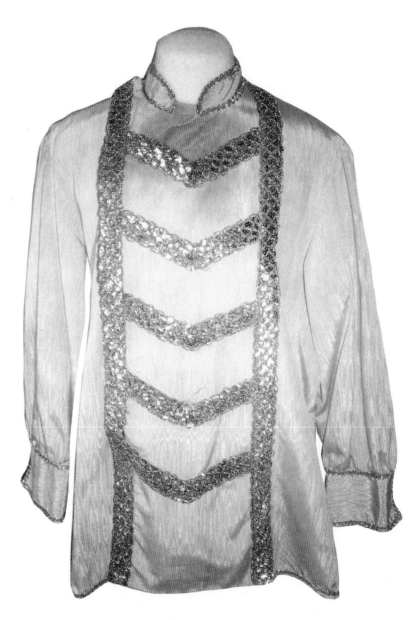

PLATE 15
Garment for male initiate
of Oshun. Shirt has wide
full sleeves. Material used
is moiré with gold trim.

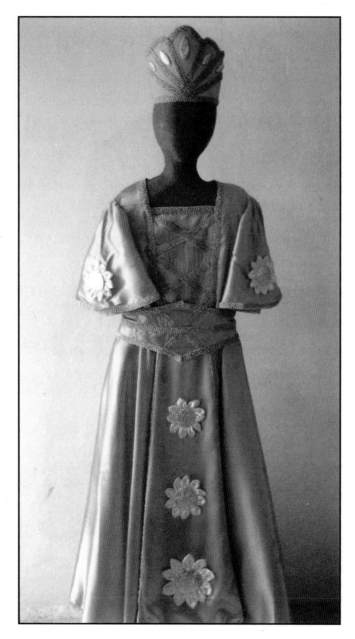

PLATE 16
Female garment for
Oshun from Puerto Rico.
Note the use of elabo-
rate gold trimming in
contrast with the more
unpretentious motifs on
the overall garment.

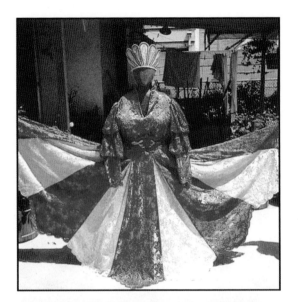

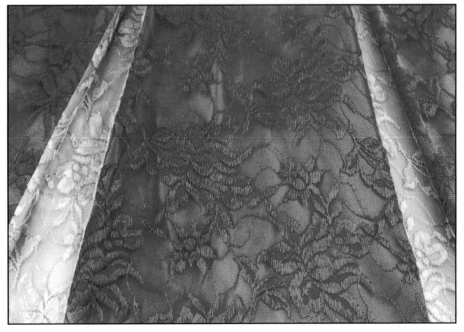

PLATE 17
Garment for initiate of
Yemaya. A-line lace skirt
with alternating panels of
light and dark blue.

PLATE 18
Detail of panels in
Yemaya garment in plate
17.

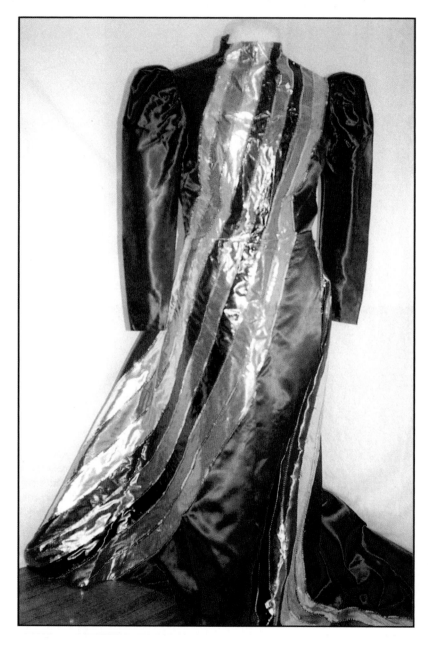

PLATE 19
Garment for Oya. Basic
dress color is burgundy
with multi-colored ap-
pliqué on front, back and
train. Constructed by
Dolores Peréz, 1991.

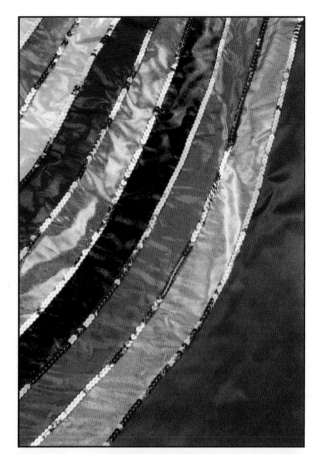

PLATE 20
Detail of Oya garment in plate 19 showing the flowing multi-colored design.

PLATE 21
Crown and belt of Oya garment in plate 19. Crown has gold trim, rhinestone and crystal beads, African grey parrot feather and multi-colored appliqué on inner surface.

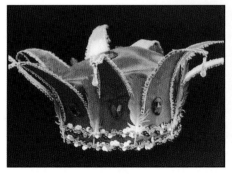

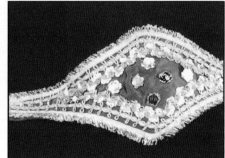

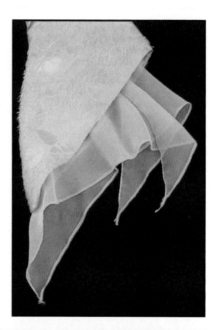

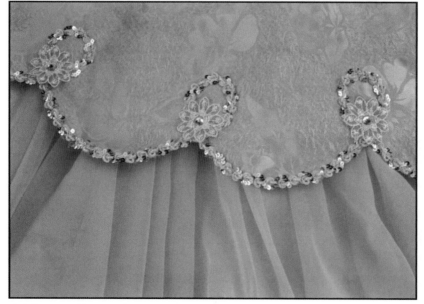

PLATE 22
Detail of sleeve for
Yemaya outfit by
Dolores Peréz

PLATE 23
Detail of Yemaya outfit
showing distinctive loop
designs of seamstress
Dolores Peréz.

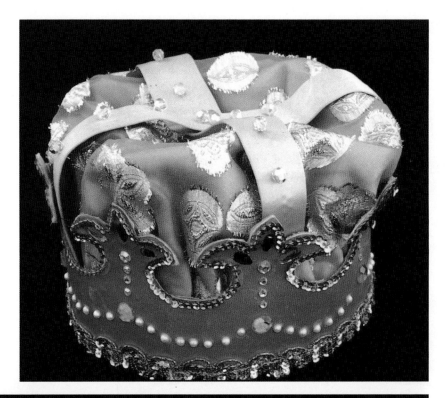

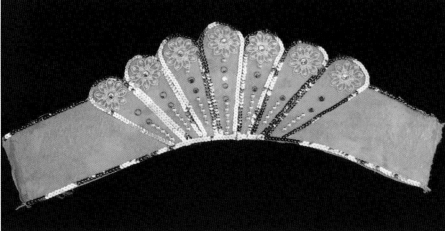

PLATE 24
Crown of Yemaya garment. Covered top of crown does not allow for flat storage.

PLATE 25
Crown for Yemaya outfit by Dolores Peréz. Made to lie flat for easy storage.

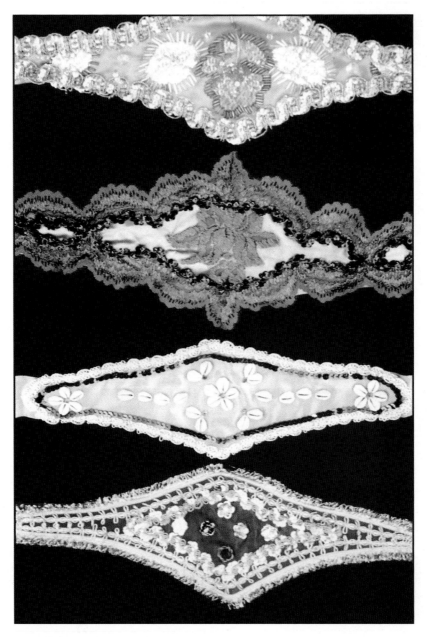

PLATE 26
Examples of belts for consecration garments. Top belt for Oya, Three following for Yemaya garments.

58

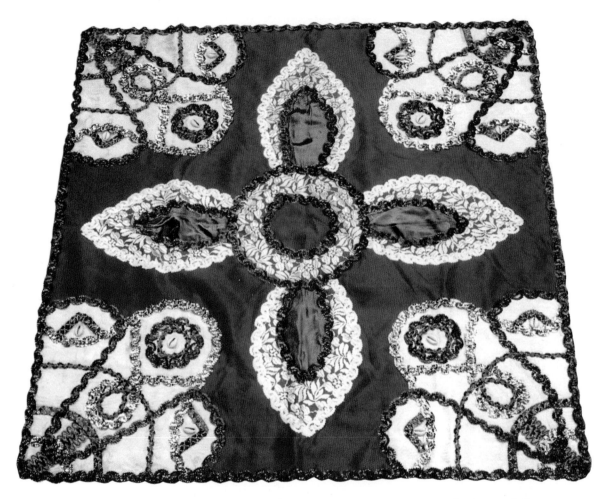

PLATE 2 7
Paño for Shango.

59

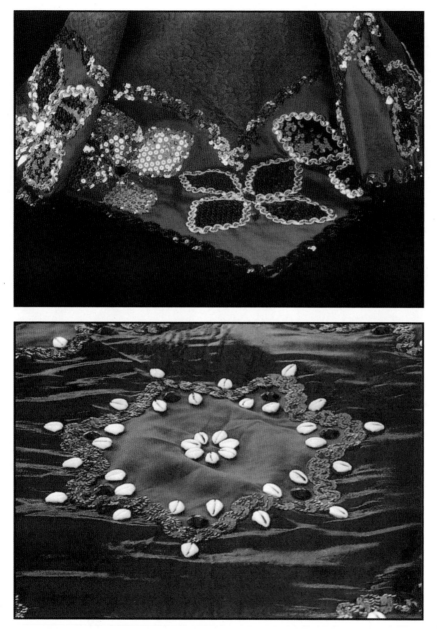

P L A T E 2 8
Detail of Paño for Oya.

P L A T E 2 9
Paño for Yemaya.

60

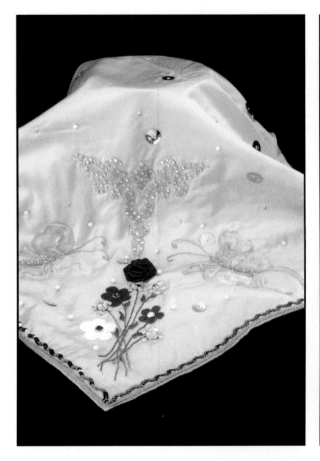

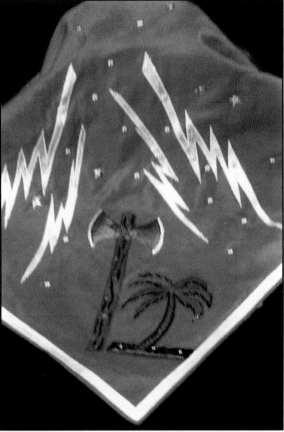

P L A T E 3 0
Paño for Ochun.

P L A T E 3 1
Detail of Paño for
Shango.

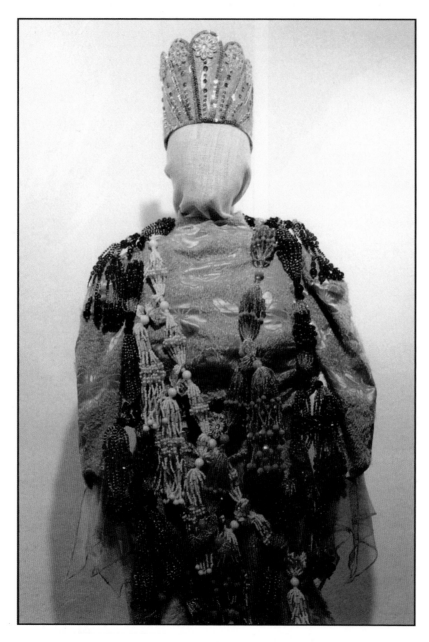

PLATE 32
Initiation garment for
Yemaya with the tradi-
tional mazos criss-
crossed over the dress.

62

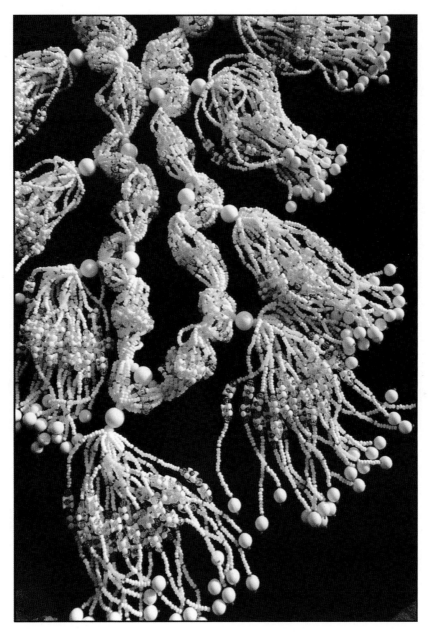

PLATE 33
Mazo for Obatala (detail).
Notice the harmonious
use of multiple sizes of
beads to represent the
Orisha.

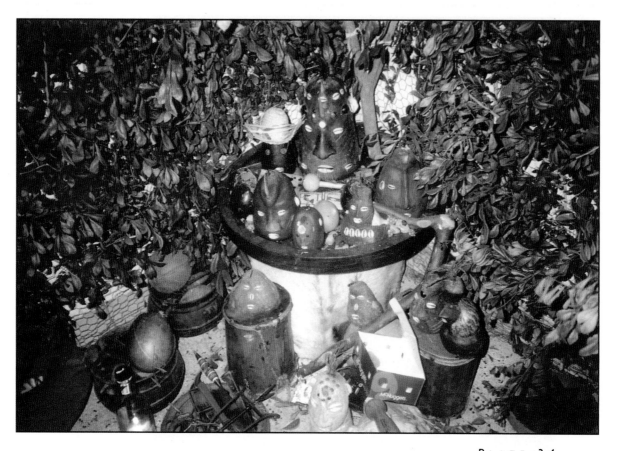

PLATE 34
Permanent altar for
Elegua at the Yoruba
Temple in Caracas,
Venezuela, containing in-
dividual Eleguas for family
members.

64

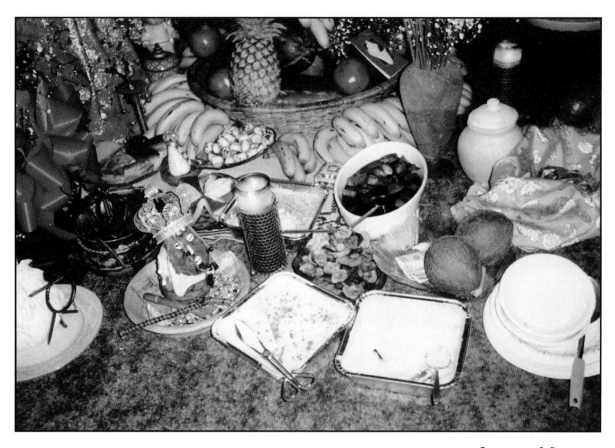

PLATE 35
Plaza located in front of
celebratory altar. Note
the fruit, pastries and
home-cooked food.

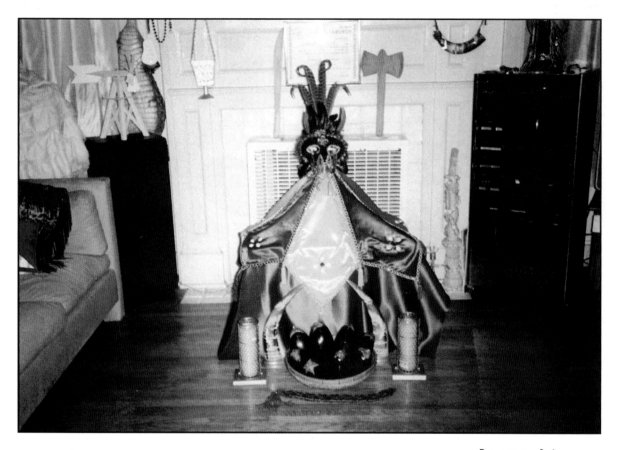

P L A T E 3 6
Altar for Oya construct-
ed by Odo Femi on the
feast day of the goddess.

66

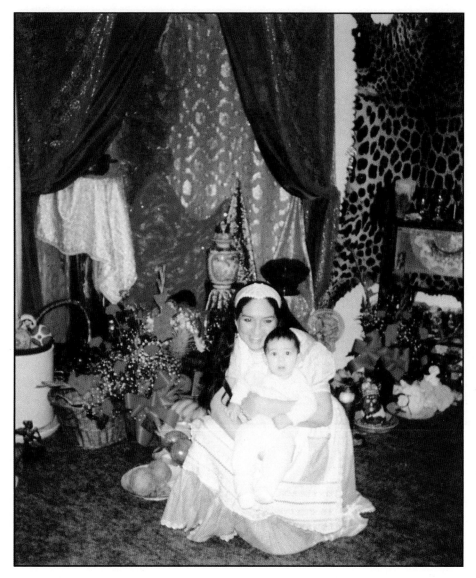

PLATE 37
Mrs. Dorothy Flores in front of her anniversary altar for Yemaya with her son, Ariel. The priestess is wearing a gingham dress in the color of her Orisha.

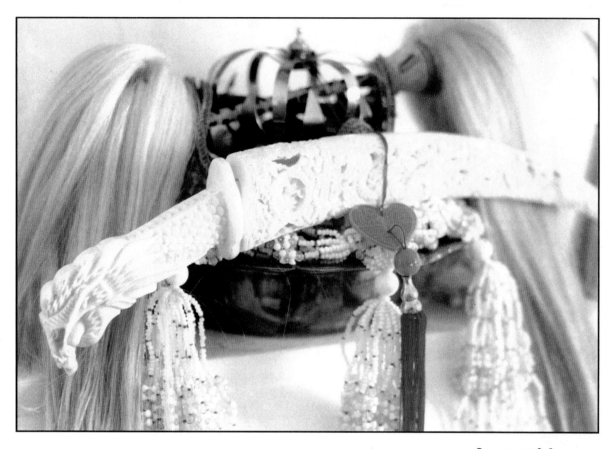

P L A T E 3 8
Permanent altar for
Obatala belonging to
Ysamur Flores-Peña.

PLATE 39
Anniversary altar for
Oshun constructed by
Ysamur Flores-Peña.
Note the forceful use of
space and decorative elements.

69

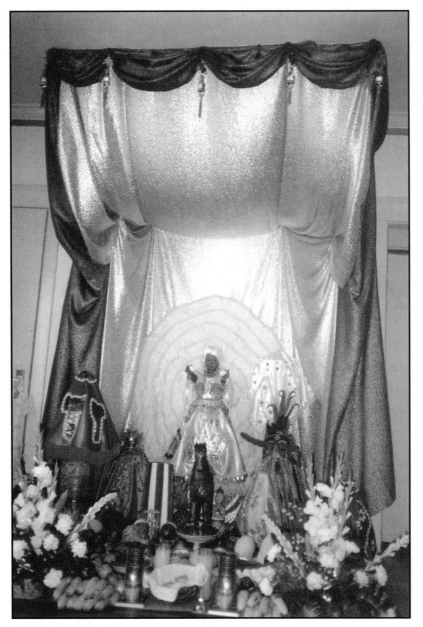

PLATE 40
Anniversary altar for
Oshun constructed by
Ysamur Flores-Peña for
Odo Femi. Note use of
paños to cover and deco-
rate the Orishas posi-
tioned within the throne.

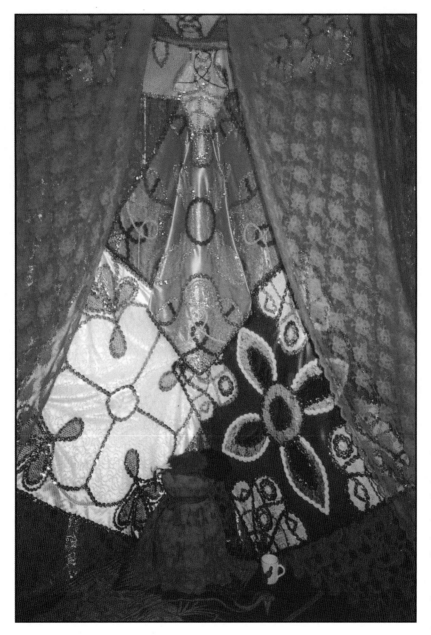

PLATE 41
Backdrop for Yemaya
consecration altar con-
structed by Ysamur
Flores-Peña in Caracas,
Venezuela. The paños in
this altar act as a repre-
sentation of the Orishas
rather than a covering as
in Oshun anniversary
altar (plate 40).

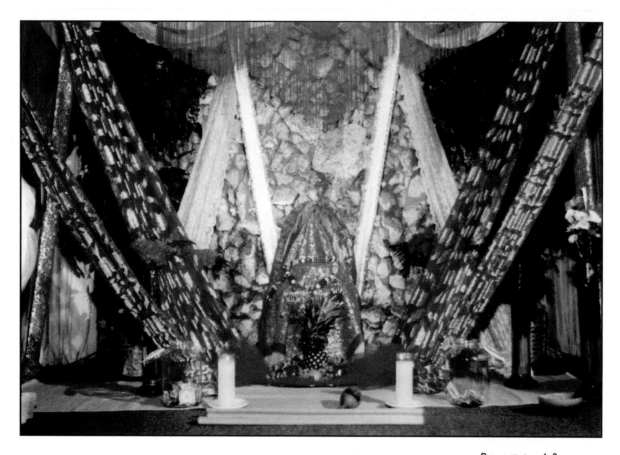

PLATE 42
Shango celebratory altar from Miami. Built in appreciation for Supreme Court decision on animal sacrifice. Top of altar shows representation of fiery falling stars.